Oil
Creative
Techniques

First edition for the United States, its territories and possessions, and Canada published in 2008 by Barron's Educational Series, Inc.

© Copyright of the English edition 2008 by Barron's Educational Series, Inc.
Original title of the book in Spanish: *Óleo creativo*
Copyright © 2007 by Parramón Ediciones, S.A.—World Rights
Published by Parramón Ediciones, S.A., Barcelona, Spain

Editorial Director: Maria Fernanda Canal
Assistant Editor and Picture Archives: Mª Carmen Ramos
Text: Josep Asunción and Gemma Guasch
Final Editing and Writing: María Fernanda Canal, Roser
 . Pérez
Series Design: Toni Inglés
Photography: Estudi Nos & Soto, Creart
Layout: Toni Inglés
Production Director: Rafael Marfil
Production: Manel Sánchez

English translation by Michael Brunelle and Beatriz Cortabarria

All inquiries should be addressed to:
Barron's Educational Series, Inc.
250 Wireless Boulevard
Hauppauge, NY 11788
www.barronseduc.com

ISBN-13: 978-0-7641-6146-9
ISBN-10: 0-7641-6146-6

Library of Congress Control Number: 2007939264

Printed in Spain

9 8 7 6 5 4 3 2 1

CREATIVE TECHNIQUES

OIL

BARRON'S

Table of Contents

Introduction 7

Materials and Techniques 8

Paint and Supports 8
Applicators 10
Additives 12
Basic Techniques 14

Creative Approaches 23

Creative Approach 01: Background Color
Using background color to create visual unity 24

Creative Approach 02: Sfumato
Chromatic atmosphere based on a floral theme 32

Creative Approach 03: Flat Painting
Synthesizing a portrait using flat areas of color 40

Creative Approach 04: Textures
Texturing the material to add density and body to a landscape 48

Creative Approach 05: Glazing
Representing the subtlety of cloudy peaks by glazing 56

Creative Approach 06: Gesture Painting
Representing the human figure with dynamic brushstrokes 64

Creative Approach 07: Impasto
Dense color in a Nordic landscape 72

Creative Approach 08: Optical Mixing
The expressive possibilities of Divisionist painting 80

Creative Approach 09: Modeling
Modeling apples using their basic structure 88

Creative Approach 10: Monotypes
Painting on a plate to print a unique work on paper 96

Creative Approach 11: Glacis
Applying glacis to create transparency in a still life 104

Creative Approach 12: Tenebrism
Using tenebrism to add intimacy in a maternity scene 112

Creative Approach 13: Manipulation
Manipulating materials to paint an old, worn stairway 120

Creative Approach 14: Mixed Media
Abstraction as the ideal space for mixing mediums 128

Glossary of the Elements of Artistic Language 136

Form 136
Color 138
Space 140
Line 142

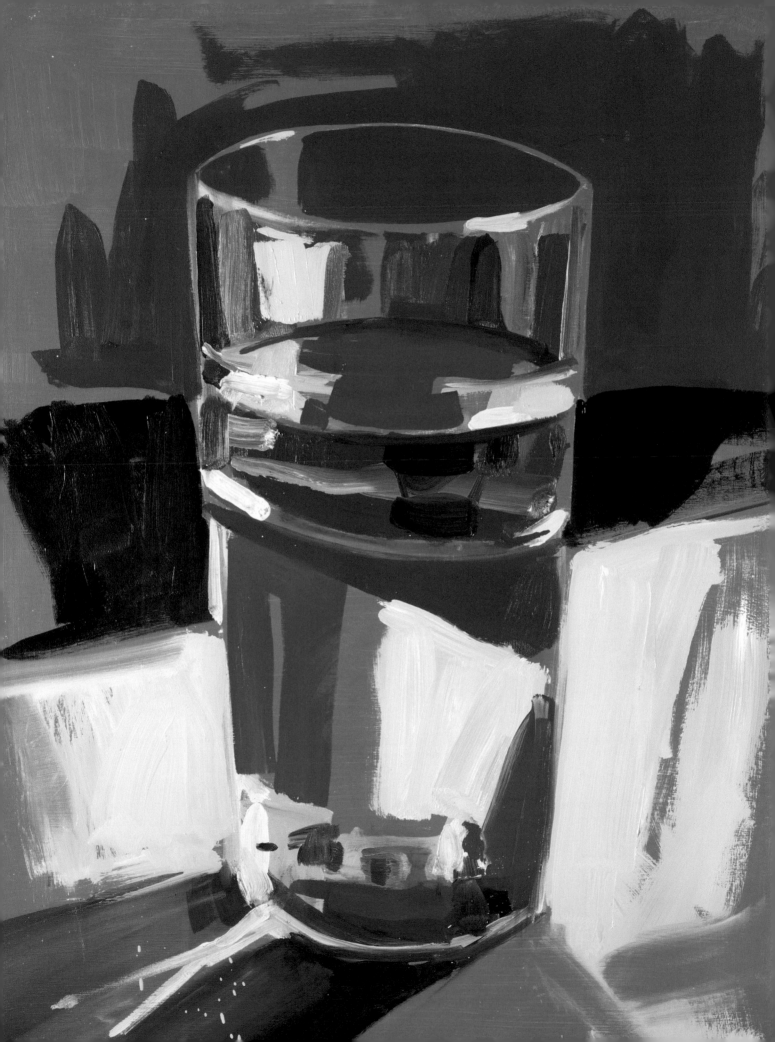

Gemma Guasch and Josep Asunción

Both are artists and professors of painting in the Escuela de Artes y Oficios de la Diputación de Barcelona. These creative people work in the field of contemporary painting and new artistic language: the art of action, video art, and photography. They have exhibited their work in various cities in Spain and Europe. Their experience as teachers, and their success in artistic creation and research is the basis for the contents of this book. Gemma Guasch and Josep Asunción are also the authors of the books *Form, Color, Space,* and *Line* in the Creative Painting Series, also published by Barron's.

Introduction

Oil painting first appeared in the Middle Ages; however, the techniques were not fully developed until the fifteenth century. It was invented by the Van Eyck brothers who began using oil to agglutinate or bind their pigments, and thus improved the detailed effects typical of their style. In the beginning, oil paint was used to finish works begun with tempera paint, but soon it became an autonomous medium that was used by most of the Renaissance artists to create oil paintings, among them the famous *Mona Lisa* by Leonardo da Vinci.

With oil paint the brushstroke was liberated; impastos and a new appreciation for brushstroke and atmosphere came into being. Gradually the artwork became more painterly. There was an appreciation of the silky texture of the paint's finish and the liveliness of its colors. A new support became popular, the canvas. It allowed the creation of work in large formats that until that time were only possible in architectural altar retables and murals.

Over the centuries new materials were discovered, known techniques were advanced, and new techniques were developed. Occasionally the advances were a starting point for new styles and artistic languages, while at other times they were a response to them. This book is positioned on this balance point between tradition and research.

This book will be a great help to those of you that wish to approach oil painting through the technical aspects, in hopes of exploring all the creative possibilities the medium offers. In these pages the basics of every oil technique explained are in a very clear style. In addition, there are a series of creative approaches and practice exercises for experimenting with form in an expressive and personal manner.

This book has three parts. In the first, the basic materials and techniques of oil painting are introduced and illustrated, and the foundation is laid for the experimental and practical work that makes up the second part. The third part is a glossary of artistic concepts related to the basic elements of visual language: form, color, space, and line.

The practice work is based on fourteen creative approaches that are proposed to the reader. A different technique is developed in each one of these approaches (glazing, sfumato, texture, etc.), based on the historical reference of a painter and on a visual model that inspires the creation of a series of oil paintings with variations of that same technique. The step-by-step development of one of those paintings is explained clearly and in detail to fully understand the process of creation. Finally, other possibilities are shown, based on another visual model or approaching the work from a different chromatic or compositional focus.

Paint and Supports

PAINT

Printed information appears on the side of a tube of oil paint: the color (cadmium yellow, cobalt blue, etc.) and some codes that indicate the pigment that was used, the amount of opacity, and the paint's resistance to light. The two latter factors are expressed with stars, bars, or numbers; the greater the number or number of stars, the greater the resistance.

Transparency

The transparency of a color depends on its pigment. When mixing, the opaque colors overpower the transparent ones; however, a transparent color does not necessarily have little coloring power. Carmine, for example, is very transparent but has strong tinting power when mixed. Geranium red, on the other hand, is very transparent and is quickly tinted by any color that is mixed with it. A little white must be mixed with a transparent color to make it opaque.

Drying

Oil paint dries by oxidation. In contact with air it forms a film, making it dry very slowly, especially if the paint is thick. The drying time is not the same for all pigments. The earth colors dry quickly, but titanium white and ivory black are very slow drying. It is a good idea to keep this in mind to avoid putting layers of fast drying paint over slower drying ones as they will end up cracking.

Various oil paint containers

A Basic Palette

A color palette should always have:
• Pure black and white
• A basic range of luminous colors for mixing bright color ranges: lemon yellow, a bright red (cadmium red medium, vermilion), a luminous blue (cyan, ultramarine, cobalt), and a pure green (emerald, permanent)
• Some earth colors: at least one with a yellow tone (raw sienna, yellow ochre), one with a red tone (burnt sienna, rust red), and a gray tone (Payne's gray)
• And finally, a small group of colors with very dark pigments that can be combined to create very rich tones (dark scarlet madder, Prussian blue, sap green, burnt umber)

Besides these basic colors, a painter usually adds other special colors to this palette to which he or she may have a personal preference: naples yellow, cinabrio green, cobalt violet, geranium lacquer, Van Dyck brown, etc.

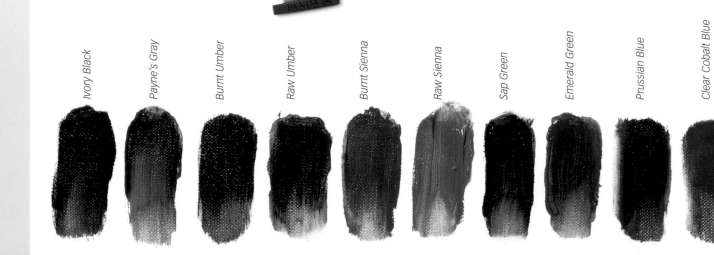

Ivory Black | Payne's Gray | Burnt Umber | Raw Umber | Burnt Sienna | Raw Sienna | Sap Green | Emerald Green | Prussian Blue | Clear Cobalt Blue

SUPPORTS

Canvas

Canvas stretched on a wood frame is the most traditional support for oil paintings. The most common canvases are made from linen, cotton (or a mixture of the two), and jute. Linen is the best quality fabric—permeable, strong, and stable—and its tension will not change despite variations in its environment. Cotton is a durable and adaptable fiber, and it can be stretched; it is the most used fabric but it is not as stable under changes in the environment, such as temperature and humidity. There is canvas fabric available that is a mixture of these fibers. The weft is linen and therefore environmentally stable, and it is less expensive than pure linen. Jute canvas is hard, rough, and strong, but more rigid, which makes stretching it on a frame more difficult.

Wood

Wood that has been primed is another very acceptable support that offers a natural texture. It is more rigid than canvas, making it better for working with textures, impastos with fillers, scraping, and very heavy brushstrokes. Ensure its stability by gluing it to a support frame, especially if it is thin.

1. *Unprimed jute, linen primed with transparent glue, and unprimed cotton.*
2. *Linen, mixed linen and cotton, and cotton, all primed.*

Paper and cardboard

Paper and cardboard are not good supports for oil paint; they do not absorb the oil well, causing the color to have a matte finish. The oil will often separate from the pigment, leaving a ring around it. The acidity of the oil will greatly damage the fibers of the paper and cardboard, turning them dark and eventually making them brittle, unless they have been well primed to create a protective layer. You can apply a layer of transparent (animal, vegetable, or synthetic) or opaque glue, or work with products that are already prepared like fabric-covered cardboard and papers that are especially made for oils.

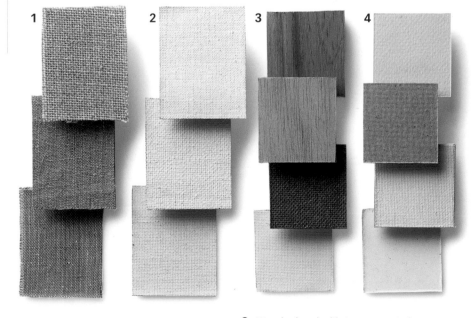

Carmine Red

Medium Cadmium Red

Cadmium Yellow Lemon Hue

Titanium White

Basic Palette

3. *Wood primed with transparent glue, unprimed wood, pressboard, and canvas board.*
4. *Paper, recycled cardboard, paper with fabric, and cardboard primed with transparent glue.*

Creative techniques **oil**

9

Applicators

BRUSHES

The brush is the painter's main tool. The quality is determined by the grade of its components and the assembly of those parts.

Components
Each brush has three parts: handle, ferrule, and hair or bristle.

Handle. The quality of a handle is determined by the quality of the wood and its lacquered or varnished finish. They are also made of acrylic or plastic.

Ferrule. Glue and the pressure of the ferrule are what hold the brush's hair. The ferrule can be made of aluminum or copper; the best ones are chromed to prevent oxidation. Well-defined rings hold the ferrule securely to the handle. The ferrule also influences the shape of the brush hair.

Hair or bristles. For oil painting the bristles should be flexible and somewhat rigid because they are for an oil rather than a water medium. The hair can be synthetic or of animal origin. The most commonly used animal hairs are sable and hog bristles, although ox ear, badger, pony, goat, squirrel tail, and Siberian mink tail are also used. Today many synthetic hairs can perfectly imitate natural ones.

Hog bristle brushes
Hog bristles are most commonly used for oil painting. They are taken from the back and abdomen of the hog. The finest and most elastic are the best quality bristles.

Sable hair brushes
Red sable hair is the most prized by artists because of its softness and flexibility, which allows it to easily recover from deformation. It is good for making light and continuous lines because it holds a lot of paint; it's ideal for delicate work.

Forms
There are many variations, but the most common are round, flat, and filbert.

Round. A conical ferrule holds the hair in a cylindrical shape. This allows freedom of movement and the creation of fine and heavy lines according to the number of the brush.

Filbert. The hair is shaped like an almond. It makes straight, uniform, and heavy brushstrokes according to its number. The strokes can look like those of either a round brush or a flat one, depending on how it is held.

Flat. The hair is held flat by a flattened ferrule and has a square tip. The flat brush is most used for oil painting. It holds less paint than the round brush and it is very good for making outlines. It works best with even pressure during the stroke, creating long and uniform lines.

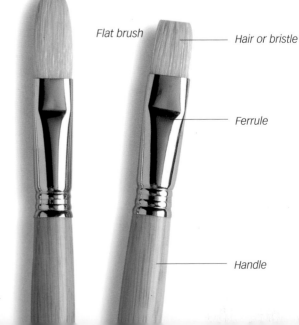

Round brush

Filbert brush

Flat brush

Hair or bristle

Ferrule

Hog bristle brushes

Handle

O il painting can make use of countless resources for applying strokes: artist's brushes, house painting brushes, spatulas, rags, sponges, toothbrushes, even fingers. Each applicator creates a different effect according to its size and material composition. The main applicators are grouped in three large families: brushes, wide brushes, and spatulas.

WIDE BRUSHES

SPATULAS

Numeration

The size of the brush is determined by the amount of hair in the brush, and this is indicated by numbers that generally run from 0 (the smallest) to 18 (the largest), although many brands make brushes as fine as 00000 and as large as a 20 or more. The numbers should coincide in all brands, but in reality they do not, so choose the brushes in person.

Sable brushes of different sizes.

These are much wider and flatter than the numbered brushes and have short, thick handles. They are used to cover large areas and for making precise blending and gradations.

Badger hair. These have long and soft hair, which allows for excellent blends. They are always used dry and over thin layers of paint.

Goat hair. The very long, durable, and elastic hair is ideal for long lines that do not need to be precise.

Pony hair. This is very similar to ox hair (light and dark), although not as elastic. The short, soft hair is excellent for blending and gradations.

Synthetic hair. There are many types of fiber (nylon, toray, taklon, etc.) that give excellent and varied results depending on their elasticity and thickness.

Natural hog. A short, rigid, elastic hair, this is ideal for working with quantities of paint for blending and impasto.

These tools have the shape of a deformed knife with a varnished wood handle attached with a ferrule or rivets to a flat stainless steel blade that can be more or less flexible. Spatulas are used for special effects, both textured and flat. They are also used for scraping, mixing on the palette and on the canvas, and for removing paint from containers.

Spatulas of different shapes and sizes.

Badger hair

Goat hair

Pony hair

Synthetic hair

Natural bristle

Wide brushes with different kinds of hair.

Additives

OILS

These are used for making paint and for diluting it while maintaining the strength of its color; however, direct mixing can retard drying, increase the final glossiness or sheen, and yellow the color. In general, the faster the oil dries, the more it yellows. Therefore, clearer oils are used for making light colors or for diluting them; these take longer to dry.

Linseed oil. This is the most common oil, obtained from cold or hot pressed flax seeds. It has a more or less golden tone, depending on how it is made. The purified version is very clear and dries well, but has a tendency to yellow. It is usually used with a diluent. Both common linseed oil and boiled linseed oils are used for dark colors; they are faster drying but are also more yellow.

Stand oil and poppy seed oils. These are very useful oils, both with neutral tones but slower drying than linseed oil.

Walnut oil. This is ideal for making glazes since it dries quickly and does not yellow. It is usually mixed in equal parts with essence of turpentine to decrease its density.

FILLERS

These are solid substances that are added to the paint to create relief and texture. The most common fillers and the ones that work best with oil paint are marble dust, marble sand, pumice dust, carborundam, and sand. Organic and biodegradable substances like sugar, salt, and flour should not be used. An impasto medium should be added to help compact the mixture and give it body.

VARNISHES

These are resins diluted in essences or alcohols that are used to protect the paint and make the color stand out. They are applied after the painting has dried completely. The most common, called "painting varnish" or "finish varnish," is sold in jars and aerosol form in gloss or matte finish. Other varnishes used for mixing with diluted paint or working with glazes are Holland varnish, which is very dark but fast drying; dammar varnish, which is very transparent but slow drying; and retouch varnish, which is more diluted and volatile.

Varnishes

Oils

Fillers

12

Throughout history painters have used different substances that, when mixed with paint, modify its transparency, glossiness, texture, and drying time, to personalize it based on the desired paint effects.

DRYERS

These are chemical substances that are mixed with paint to accelerate its drying time. They should be used carefully since they tend to modify the color of the pigments, especially the lighter tones. Cobalt dryer is the most common, and it should be used in very small proportions, two or three drops for about a walnut size amount of paint; and only with slow drying colors like ivory black, titanium white, vermilion, and ultramarine blue.

Diluents

Mediums

Dryer

DILUENTS

These are essences and essential vegetable and mineral oils that are used to dilute oil paint.

Essence of turpentine. Also called "turpentine," this is the most common vegetable essence, the product of distilling pine resin. It is transparent and slightly yellow, with an intense odor, and it is toxic. Be aware that there are thinners on the market that are not at all acceptable because they are highly corrosive and irritants. Another newly created essence is made from orange peel; it has a pleasant odor, but a higher price.

MEDIUMS

Manufacturers sell preparations that combine oils, essences, resins, and other substances in certain proportions to create different effects. Known as mediums, they increase adhesion and aid the paint in hardening without altering it. They are normally sold in jars, but are also available in tubes. The most common are Flemish dryer, made of copal resin; turpentine oil and linseed oil, which vitrify the pigment and add hardness and brightness; egg medium, an emulsion of oil, egg, and water that adjusts the amount of glossiness of the paint, solidifies it, and even helps it combine with water-based media; Venetian medium, which helps dry and thicken the paint and make it matte; paint medium, which combines all the substances (oil, vegetable and mineral essences, and resin) and is used for glazes; and finally, impasto medium, which is denser than the other mediums and used for creating impastos without modifying the color. Impasto medium is composed of Flemish dryer, water, and filler; the resin in the mixture vitrifies the dry paint and enlivens the color.

Basic Techniques

PREPARING BASE COATS

Choosing the support

This is the first step when beginning a painting. Canvases prepared by manufacturers are generally used, and the artist should experiment with the wide range that is available. Working on jute is not the same as working on linen with a transparent primer, rough cotton, or a smooth fabric with barely any texture at all. Doing so will expand your creative oil painting.

It is more exciting to try working with more personalized supports when it comes to formats, materials, colors, and textures. The artist needs to know which primer to apply to the support to protect it from acidic media. But in addition to this protective function, the primer has another job: eliminating absorbency.

Priming the support

Animal (rabbit skin) or a synthetic glue (latex is the most common) can be used for priming a support. Both are transparent when dry, which allows you to make use of the natural color of the support material. For better coverage add pigment to the glue; Spanish white is often used, but you can add other more personalized colors. Fortunately, there are acrylic base primers on the market, carefully manufactured with exact proportions to ensure high levels of protection and sufficient absorption.

Polymer emulsions

In recent years manufacturers of art materials have experimented with polymer emulsions made to very exact specifications. Some of them harden the support if it is very unstable, others allow the creation of primer bases on glass, synthetic fabrics, metals, and plastics, supports that until now were not recommended. These are acrylic mediums in liquid or gel form that deserve their own chapter because there are so many available.

An acrylic primer made of polymer glue and white pigment, which is useful for porous surfaces.

Priming a raw linen canvas with acrylic base. It is important to apply it in layers and maintain uniform and smooth brushstrokes.

Mixing pigments with the base coat will create more interesting and personal colors.

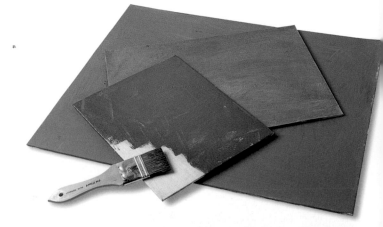

Materials and techniques

Oil is a medium that can be worked in several layers of paint, and used with a great variety of applicators and supports. By adding to these three ingredients the countless techniques that can be applied to the brushstroke (brush marks, impasto, blending, glazing, dragging, scraping, dissolving), we enormously increase the number of expressive results. It is a traditional medium, but that does not mean that the experimental possibilities are exhausted.

Amount of coverage

When preparing a base, determine how much coverage is desired—the absorbency of the surface will depend on it. This will determine the number of layers to apply. If a good covering base is used, it is preferable to apply several thin layers rather than a single thick layer. In this case, after one layer the next is applied in another direction, applying brushstrokes perpendicular to the previous coat to equalize the tension and cover the surface well. With wood it is a good idea to apply the primer to both sides to avoid warping caused by uneven tension and the humidity of the glue.

Using leftover paint

Many painters prime their supports with leftover paint from their palette, usually a suggestive neutral color, or with a mixture of this recycled paint and putty, to create texture. By applying an oily primer of this kind, you eliminate its absorbency but do not really protect the support. It is a risk that you can take as long as you are aware of this fact.

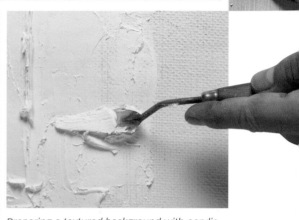

Preparing a textured background with acrylic medium. This adds thickness and allows the creation of textures. It can be added to acrylic paint, but not to oils. In the latter case it must be applied as a base that can be painted later.

Preparing an oil color background on a metal base. The roller creates a uniform color. A coat of retouching varnish can be applied first to ensure good adhesion of the paint.

Recycled base coat on pressed cardboard. The accidental drips are integrated into the work and give it a natural feeling.

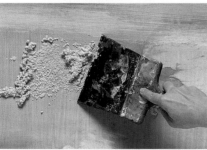

Preparing a textured base on wood previously primed with gesso. Start with an acrylic base prepared using latex, marble sand, pigment, and water. The texture can be distributed according to the design of the painting, or left to chance.

Basic techniques

CREATING BRUSHSTROKES

Generally, the variations in a painted line depend on four factors: the applicator, the amount of paint, the speed, and the shape or movement the painter makes to apply the stroke. There are no exceptions for oil paint, but there is one additional important consideration: drying. Because of its ingredients, oil paint takes a long time to dry, resulting in both inconveniences and advantages. On one hand, it does not allow one application after another since the paint builds up quickly on the canvas; on the other, it does allow rich blending, atmospheric effects, and the opportunity to make adjustments.

Dry on dry

The paint can be worked just as it comes from the tube or its density can be reduced with oil, diluent, or medium. In the first case, the paint is creamier and makes a dense brushstroke that shows the texture of the support after drying. This technique is called "dry on dry" and is used to create a rough look that can go from watery to heavy according to the amount of paint in the brush.

Wet on dry

If a brush charged with more fluid paint is used on this dry base, the brush-stroke will be more viscous; it will leave rough edges and spatter, although the texture of the support will not be visible. This approach is called "wet on dry."

Wet on wet

When the coat of paint is still fresh and wet you can continue with another stroke that is wet and oily like the surface of the painting. This method of working is known as "wet on wet." The colors will blend with each other, and in the stroke itself if the brush holds a lot of paint. This is the usual way of working, since the oil stays wet for a long time. Be very careful and do not go over the brushstrokes, since they will quickly mix and become blended, sometimes in an amorphous way that can muddy the colors.

Choosing the applicator

Consider the size and shape of the brush to envision the shape of the brushstroke; the brush's stiffness will determine whether the mark made is soft or hard. To create a viscous stroke with no hint of the bristles, you can use your fingers. For a textural effect, create applicators for the occasion with rags and objects to make marks and impressions on the canvas. Another very effective applicator that creates a sense of texture is the spatula, which drags the paint to create white areas, leaving thicker paint on the edges.

Finally, there are very direct and expressive alternatives, for example, applying paint directly from the tube or from an oil paint stick. Once the paint is on the support, continue building it up or blending it with a brush, spatula, fingers, a rag, etc.

1. *Marks made with a rag*
2. *Oil crayon marks*
3. *Paint direct from the tube*
4. *Finger mark*
5. *Mark made with a spatula*

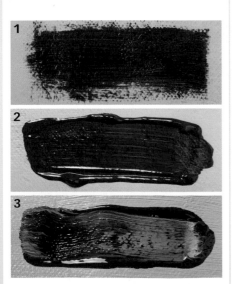

1. *Dry on dry brushstroke*
2. *Wet on dry brushstroke*
3. *Wet on wet brushstroke*

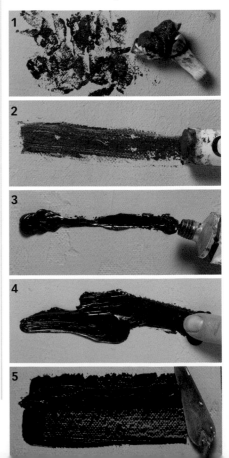

DILUTING COLOR

Oil paint can be diluted in three ways: with medium, oil, or diluent (essence of turpentine). Each method will create different effects. Many painters choose to dilute paint in a mixture of turpentine and oil and always have both on hand and very clean; using both will avoid excess drying and giving the color too matte a finish.

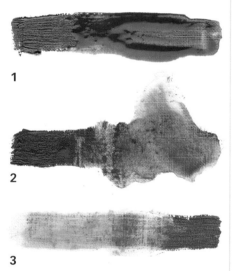

1

2

3

1. Diluting the paint with a medium will make it more fluid and viscous while conserving its intensity, chromatic density, and brightness.

2. When we use solvent to dilute paint the solution is more liquid, the finish is more matte, and the color can break up.

3. Diluting the paint with oil will make the paint more transparent, although it will yellow a little and drying will be retarded. The finish will be oily.

CREATING EFFECTS WITH LITTLE PAINT

Working with very diluted paint increases the transparency and subtlety of the brushstroke. This way of working is known as "glazing," and the finished work is a series of thin layers, like silk or gauze veils that allow light and color to pass through. Oil paint can be used to make marvelous rich glazes that include matte and liquid effects with oil, satin, and glassy finishes. The artist plays with transparency, blending, gradating, washes, dilution, and related effects like drips and splashes.

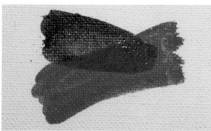

Glaze with overlaid transparent colors. Success depends on whether the paint was allowed to dry between applications.

Blended color over wet paint. Take advantage of the fluidity of paint diluted in oil or medium to spread a second color over the first.

Intentional dripping made with a paint charged roller.

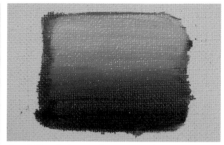

Gradation between two wet colors. To create this effect, work with diluted paint and spread it with a light zigzag motion.

Oil stick lines diluted with turpentine. Oil sticks are always applied dry on the support, but later can be diluted using a brush with solvent.

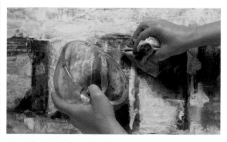

A white glaze wash allows the previous layer to show through. Applying a thin coat of color on a dry background will create a translucent glaze.

Creative techniques **oil**

Basic Techniques

CREATING EFFECTS WITH THICK PAINT

Impastos and textures, made with heavy applications of oil paint, are the extreme opposite of glazing. Keep in mind that creating such heavy effects will greatly increase the drying time of the painting, and as a consequence it will be difficult to work in layers unless dryers are added to the paint.

The main techniques of this style of painting are impasto, dragging, and removing paint. It is as simple as adding paint, dragging it across the surface, and removing it by scraping, wiping, or sgrafitti. The color can be pure paint, paint with a medium, or paint with a textural filler, normally mineral dust or sand. The impasto, dragging, and removing will be different depending on the paint mixture itself.

Mixture of impasto medium and paint. Impasto medium is an ideal medium for adding volume to paint without changing its opacity or color. In addition, the resin in the composition encourages drying and hardens the paint.

Unless textural filler is added, brushstrokes of oil paint in a creamy or pasty state will show rough edges and irregularities in the surface, revealing the applicator used. These effects are of intrinsic value to the oil, adding a material lyricism and expression to the stroke. A small amount of dryers can be added to compensate for the increased drying time, or impasto medium, which has dryers among its ingredients, can be used. Pure oil paint applied very heavily takes a very long time to dry—even years!

Adding fillers to create textures will resolve this problem, and the oil will totally integrate the texture of any material. After it is dry it might look like cement or construction plaster if marble dust or pumice have been used, or sandpaper if fine sand was added, or dirt if it was marble sand or carborundum. These help the paint dry because they absorb the oils very well, but they are less glossy. If a paste medium is added to these earthy ingredients, the characteristic gloss will not be lost.

Adding filler to the paint, such as this marble sand, changes its textural aspect and helps it to dry.

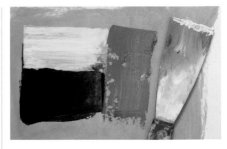

Impasto with scrapers. *The stroke is wider and more uniform than one made with a spatula. The scraper is very useful for large areas of paint, for dragging and scraping large uniform areas, for sharp details, and for long and small white areas without color.*

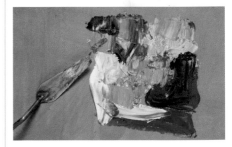

Impasto with spatula. *The spatula is more useful for detail work and short strokes. The colors have a rough and confused look.*

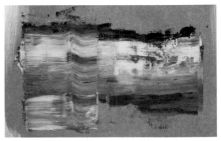

Dragging several colors with a scraper. *The more the scraper is dragged through the paint, the more the colors mix and the sharpness of the stroke is lessened. Moving the scraper up and down will create a zigzag effect.*

BLENDING PAINT ON THE CANVAS

The final result of the painted image greatly depends on how the strokes of paint are combined, how much the paint is blended, and how the blending was done. If the blending is very atmospheric the image will be softened, and even blurry; if it is impasto it will be expressive and choppy; if there is no blending the strokes are flat and separated. It is interesting to experiment with different blending techniques on the canvas to explore their creative possibilities.

Natural blending of two colors with the same amount of viscosity in the paint barely diluted with a small amount of essence of turpentine, using a hog bristle brush. A third color is created in the area between the original colors because of the fluidity of the medium.

Blending two liquid colors. The paint has been diluted with a large amount of turpentine, which disperses the color and allows the support to show through. This is more of a lighter, watercolor effect than is normal for oil painting.

1

2

Blending two thick colors with a spatula directly and without going over them several times leaves the paint smooth and the color unmixed. Very interesting relief is created in the area where they are in contact (***1***).

Lightly passing the spatula several times across the paint creates a color mixture and a textural effect that leaves one color over the other (***2***).

Blending two colors applied with a lightly charged, dry brush. The result is rough and atmospheric, like a cloud of dust. To create this effect the brush is applied lightly, leaving bristle marks.

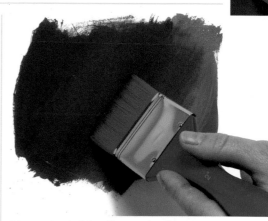

Atmospheric blending *made with very light strokes of one color over another. The brush should have very soft hair (like badger, ox hair, or synthetic) and be very dry. This is the best way to create sfumato.*

Blending by hand *from an oil paint stick. The warmth in the fingers helps soften the paint and build it up as much as desired.*

Basic Techniques

REMOVING PAINT

Painting is not just applying paint to the canvas, but removing it as well. Lines can be created by adding and subtracting material. Paint is subtracted the same way it is added, but the resulting texture is different. Erasing, scraping, and wiping cause very natural textures, accidents, stains, and color blending.

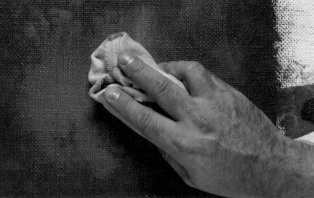

If the support does not have very much texture, and the layer of oil is thin, apply this subtractive technique consisting of lightening areas with diluent. First dampen the painted surface with pure diluent; in this case drops were used. Next, use a rag to remove the paint that has been softened by the solvent, by dabbing or wiping, whichever works best.

Direct wiping *with a rag creates areas with gradations within. In this case, a dark area has been opened up, uncovering a brighter layer underneath.*

Removing paint with a spatula *scrapes the underlying paint, which is a base color on the support.*

If the paint removed with a spatula is wet, the remaining paint will show liquid effects, even when dampened with diluent. A little marble sand was added to enrich the paint.

A sponge *can be used for erasing if the oil paint is very thin. The effect is not as strong as with a rag, since the sponge is a softer applicator and is more porous. This technique would have more aggressive results if the sponge held some diluent.*

BLENDING IN THE RETINA

COMBINED MEDIUMS

Sgraffito is a scraping technique used to create a drawing. Two layers of color are used. When the first layer is very dry, a second thick, heavy layer is applied. Then, it is scraped to make the first layer show through. Lines will result if a pencil or the tip of a spatula is used; larger areas will be exposed if a spatula is used.

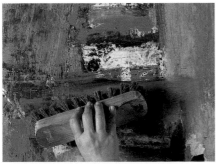

Scraping the painted surface with rough and rigid applicators can make very attractive textural effects. Imperfections and accidents will occur. In this case, the paint has been removed with a hard brush.

Paint can also be mixed in the retina of the viewer. The Impressionist painters were the first to use this blending technique. If you look at small dabs of blue and yellow paint instead of a large area of green, for example, you will perceive three colors: the green, which is blended in your retina, the blue, and the yellow, with all their brightness. This method offers the ability to maintain the light of each color rather than neutralizing them. In addition, the final result is very rich in shades since the colors show through each other without being darkened in physical mixtures.

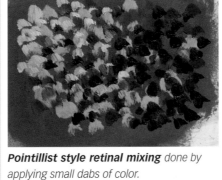

Pointillist style retinal mixing done by applying small dabs of color.

Mixing by glazing. The glazing technique consists of working with transparent layers of paint so that the colors are not very opaque and allow underlying color layers to show through.

Oil paint can be combined with other oil-based mediums like wax, industrial varnishes, and oil-based enamels. They can even be mixed to explore the possibilities of combining different drying times, dispersion effects, crackling, wrinkling, etc. Oil can also be combined with collage or a wet technique like India ink; the results will be stranger and more experimental.

Oil with other mediums. From left to right: wax crayons, varnish, metallic enamel, anti-rust paint, and India ink.

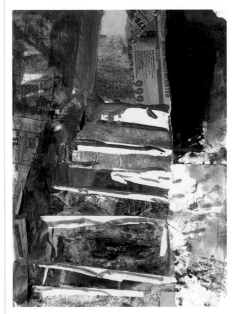

Oil and collage.

01 02 03 04 05 06 07

Creative Approaches

08 09 10 11 12 13 14

01 Background Color
Creative approach

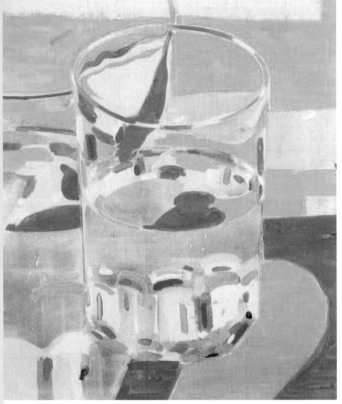

Alfonso Albacete
*Twelve Glassware
Paintings–10*, 1999
Private collection

Many painters from classicism until the present time have left colored primed supports unpainted or have painted uniformly colored backgrounds to enhance color vibrancy. A recent use of this technique can be seen in a magnificent series of oil paintings of glasses by the painter and filmmaker Alfonso Albacete (born in 1950), one of the participants in the resurgence in Spanish painting in the 1980s. Albacete shows an exceptional talent in any of the techniques he attempts. His work is influenced by Cézanne and American Abstract painting, and can be seen in the systematic and constructive brushstrokes that liberate the form of the solid structures first created by drawing. In the series titled *Twelve Glassware Paintings* he explores the limits between the background and the figure by confusing them on the picture plane. To do this he uses color harmonies based on color backgrounds that help represent the transparency of the glass.

Using color backgrounds to create visual unity

A still life of a simple glass of water is an ideal subject for experimenting with the limits between a figure and the background. The artist for this project, Josep Asunción, saw in the transparency of the glass and the water a reason to allow the background color to show through. He began with a large board primed with acrylic paint, on which he painted with oil paint. Oil and acrylic combine perfectly if used in the correct order: first acrylic, then oil, never the other way around. Brushes of different sizes were used, both flats and filberts.

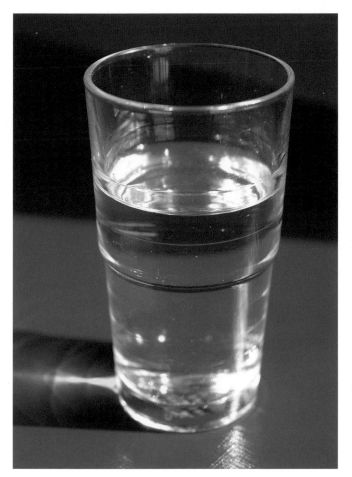

> *"I do not believe that my paintings have an abstract base. I believe it is figurative or naturalist. What happens is that I leave the field wide open to any kind of painting action that can be produced on the canvas, and this handling of the brush, color, of painting, without interfering with the subject is the only abstract component of my work"*

Alfonso Albacete, interview in *Lápiz*, 1983.

Step-by-step creation

1. *A drawing of the glass is made with white chalk on a background of intense orange acrylic. The correct proportions are maintained and the volume is centered symmetrically on an axis. Highlights are also included.*

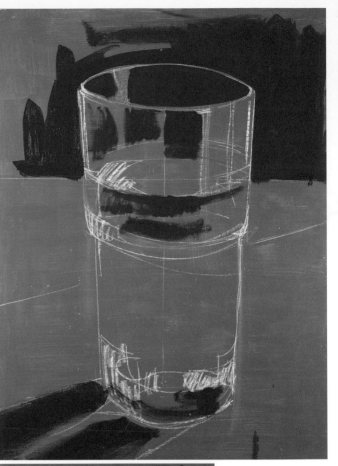

2. *Next, the background is painted with some burnt sienna, making it show through the transparent glass. The outlines are left unpainted, using the orange background to define the thickness of the edge of the glass as a transparent material. The projected shadow is laid in, leaving an open area where the light comes through the glass.*

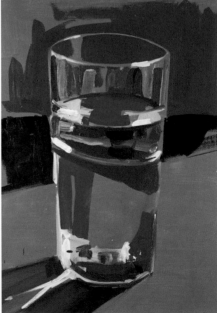

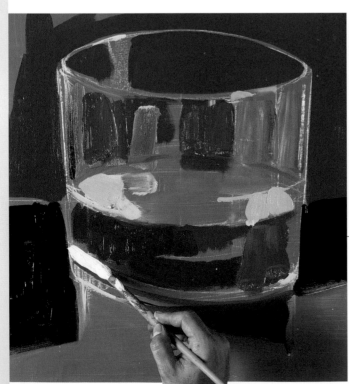

3. *The light and shadows continue to be defined with light gray, dark gray, and blue gray to create a greater chromatic contrast, since blue is the complementary color of orange. Brush size is selected based on the width of the brushstroke. Mixed strokes are made using flat brushes; others are made with filbert brushes to create contrasting finishes.*

4. *A purer color is added to define the contents of the glass. Since the water is transparent, a red color is chosen because it is in the same color range as orange. The red adds liveliness and body but does not reduce the sense of transparency. The darkest color of the base is indicated inside the glass and highlights within the projected shadow.*

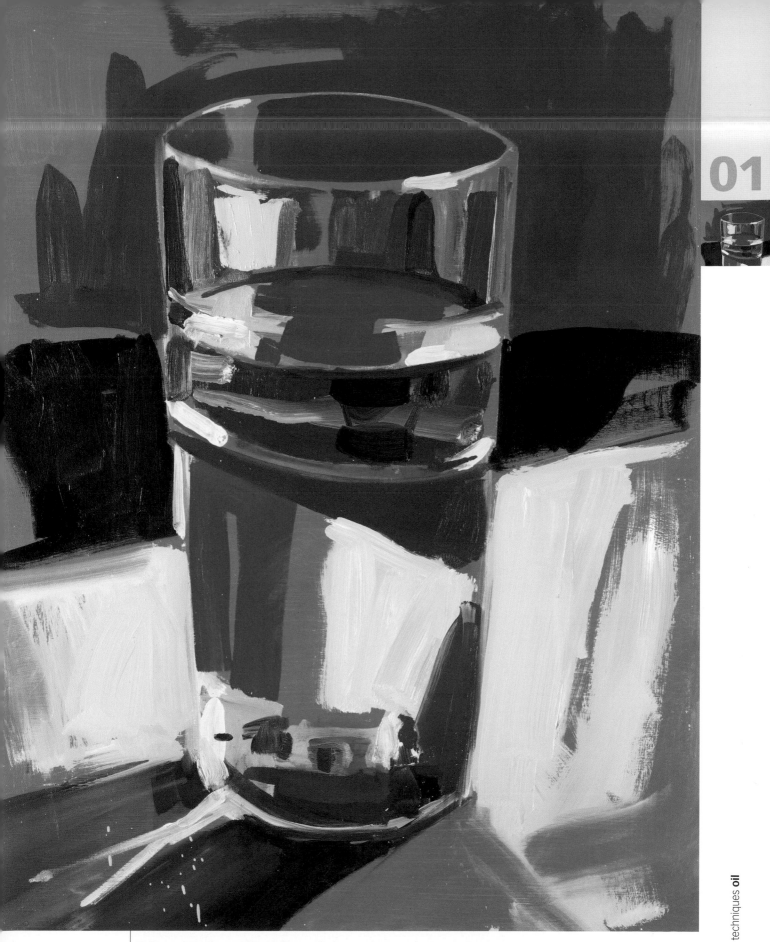

5. *The painting is completed with a radical move when it comes to contrast and that somewhat affects the realism of the work, taking it to a more informal and dynamic place. The wide strokes of bluish white paint are the perfect counterpoint that fills the painting with light and adds the finishing touches.*

01 Gallery

Other versions

This time, the artist has created various color harmonies based on different color backgrounds. He also changed his position in respect to the glass to appreciate different reflections and transparencies, because just a slight movement will greatly change the way it looks.

In this work he chose a simple color range, based on the orange background, that does not approach yellow but comes close to intense red. A filbert brush was used to blend the paint to avoid creating an excessively flat effect in the painting.

This painting was done on a blue green base. The image was strengthened by using a different angle and a lower point of view, forcing the dark background to extend down as far as the base of the glass. Some orange was added to the light to create a color contrast with the green, which is its adjacent complementary color.

This painting left more of the base color than the others. It also has the highest point of view; therefore no dark areas are seen behind the glass. The chromatic unity gives the painting a greater simplicity and at the same time a greater lyricism.

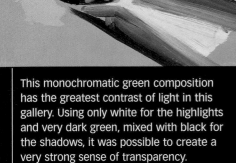

This monochromatic green composition has the greatest contrast of light in this gallery. Using only white for the highlights and very dark green, mixed with black for the shadows, it was possible to create a very strong sense of transparency.

This last painting was made using a two-color base. Blue was used for the background, and red for the plane of the table. On these two colors the glass was painted with pure white. The two colors were mixed to create darker values, resulting in a dark violet, the darkest tone of those used in this work.

Another point of view Here we have the same technique with a different point of view that is much more baroque, where the same background color is used again over previously painted work. This makes the painting fuller and denser. In addition, the edges of the glass have been painted over, decomposing the outline with a series of vigorous broken brushstrokes that are much more free and expressive. This informal treatment is more like Expressionism and Fauvism, movements that frequently exploited the color background technique in a quest for freshness and fullness.

Another model This time the artist chose a very different model, a space. It is a view of the Ganges River where it passes Varanasi, in India. The water in the river, tinted a gray brown at dusk, acts as a color background over which daily life flows. Josep Asunción wished to evoke the city at this time of day, taking advantage of the background color to create the scene.

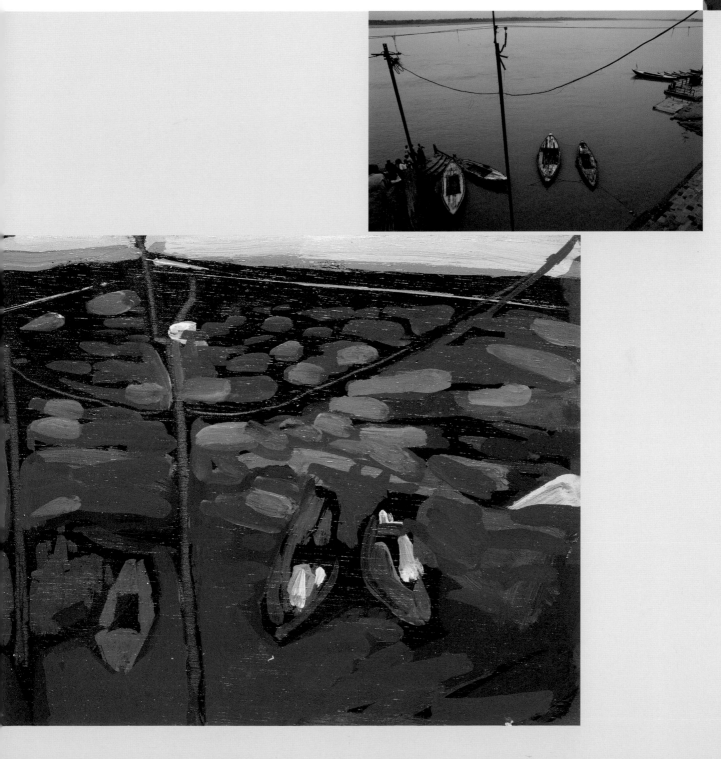

02 Sfumato
Creative approach

Gerard Richter
Blumen, 1994
Private collection

Gerard Richter (born in 1932) is one of the major names in contemporary painting. For him painting is a way of knowing and of personal expression, a space for investigating the limits between appearance and reality. Richter reflects on the ways of looking and offers us a new perception: a veiled vision of reality, unfocused and almost blurry. In this manner the artist wakes up the viewer and obliges him to search for the truth of each object; to do this he uses, among other techniques, sfumato. This painting technique was used by Leonardo da Vinci in the Renaissance to add atmospheric sensations to the painted image. In the still life *Blumen*, the painter offers a poetic vision with an enormous atmospheric charge created by using an unfocused, veiled image of perceived reality.

Chromatic atmosphere based on a floral theme

Wishing to investigate the creation of a poetic and atmospheric world, Gemma Guasch uses sfumato in a floral composition. Oil paint, a slow-drying medium, works well for creating light blending, blurry edges, and suggestive perceptions. The use of appropriate tools, soft brushes with sable, synthetic, and badger hair, applied lightly to the wet paint, gives the work an enchanting painterly feeling.

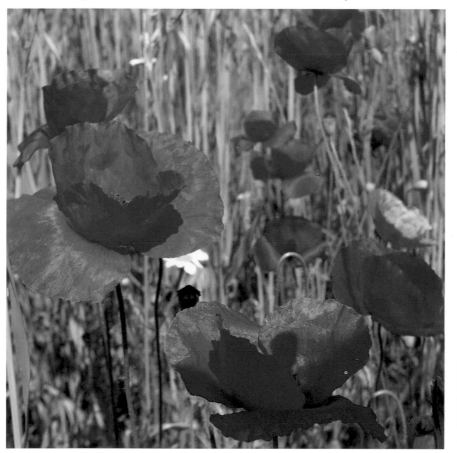

"Illusion, or rather appearance, is the theme of my life. Everything that is, seems to be, and that we see is perceived thanks to light reflected from it.

Nothing else is visible. Painting has to do with the appearance more than any other art (including photography, of course)."

Gerard Richter, *Notes,* 1989

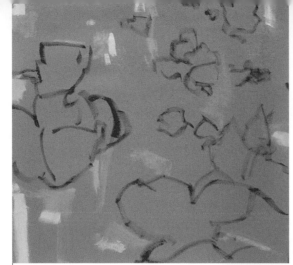

Step-by-step creation

1. The background is painted with a light green tone to give the work a warm feeling. Then, using a flat sable hair brush, the shapes of the poppies are outlined in cadmium red. Finally, green strokes are laid in with a wide nylon brush, using yellow-green and green-white tones.

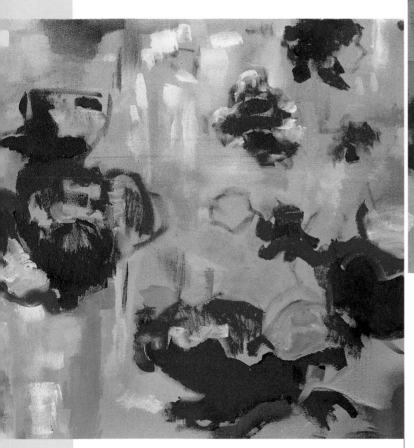

3. The wet image on the entire painting is wiped with a dry badger hair brush. This helps blend the edges, blur the image, and make it more atmospheric. The dry wide brush must be continually cleaned with a cotton rag to keep the image from becoming muddy.

2. The petals of the poppies are modeled with the flat sable brush charged with carmine and cadmium red; then finished with a light rose tone to emphasize the contrast of light. Work is continued on the background with the wide nylon brush, applying different green tones: yellow greens, light greens, and dark greens.

4. The creation of sfumato can excessively weaken the painting. The dark tones are recaptured and the energy returned to the work by applying carmine and dark green tones with the sable brush and wide nylon brush.

5. To finish, touches of white, pink, and yellow light are applied and immediately and carefully blended with the badger brush. The final result is atmospheric, fresh, and elegant.

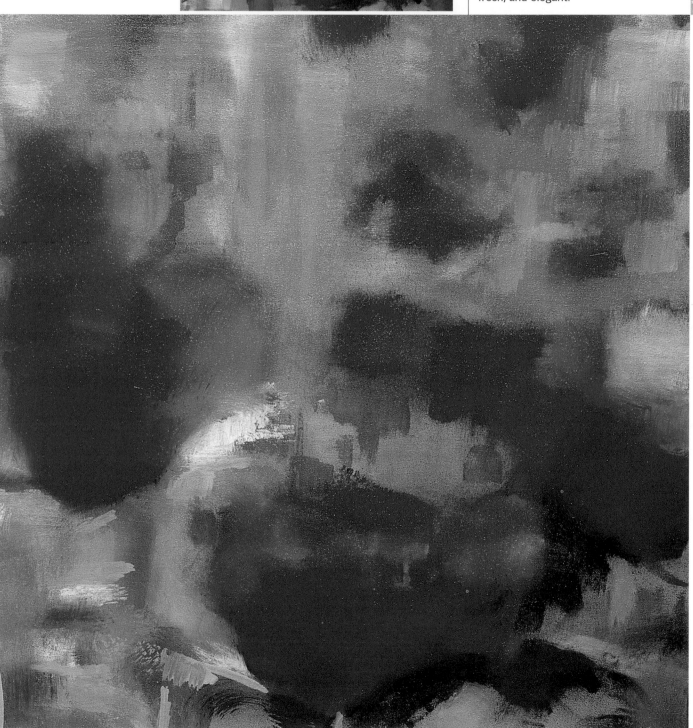

02 Gallery

Other versions

To create magic and atmospheric effects the artist can vary the applicators. Wide brushes, rags, fingers, and brushes of various sizes and hair will help enrich the sfumatos and make them more enjoyable. This gallery showcases these variations in all their splendor.

This work, done with synthetic brushes on a green background, has a soft and delicate feeling. The use of white and pink creates a more blurry vision of the floral arrangement, much like an overexposed photograph.

This painting was done over a black background with a very wide hog bristle brush. The different colors on the black background were applied dry, which favored dragging and rough and broken blending.

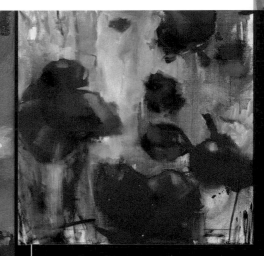

The radial motion of the brushstrokes and the use of a cotton rag for painting give the image a lively and dynamic feeling. The blending of the tones was done directly and vigorously, taking care not to mix the colors with each other, since it would lessen the strength of the yellow greens and the vibrant reds if they became grayed.

Here the yellow strongly tints the greenish background, creating an atmosphere charged with light and warmth. The flowers modeled with rounded and contrasting brushstrokes offer a more direct view. Different natural and synthetic brushes were used for this work.

A large number of different colors of paint were applied dry to a black background. Then, the sfumato was created with the fingers. The limits between the different colors were blended carefully, respecting the black outline that contrasts with the softness and creaminess of the reds and greens.

02 Window

New
approaches

Another point of view All of the previous works have been done in a square format. This format encourages uniformity and reduces tension. This time, to change the point of view the artist has chosen a vertical format that increases the tension and adds another different sensation: a fragmented view of the flowers and a greater presence of green in the background. The support has also been changed to a white handmade paper and a glossy yellow colored paper.

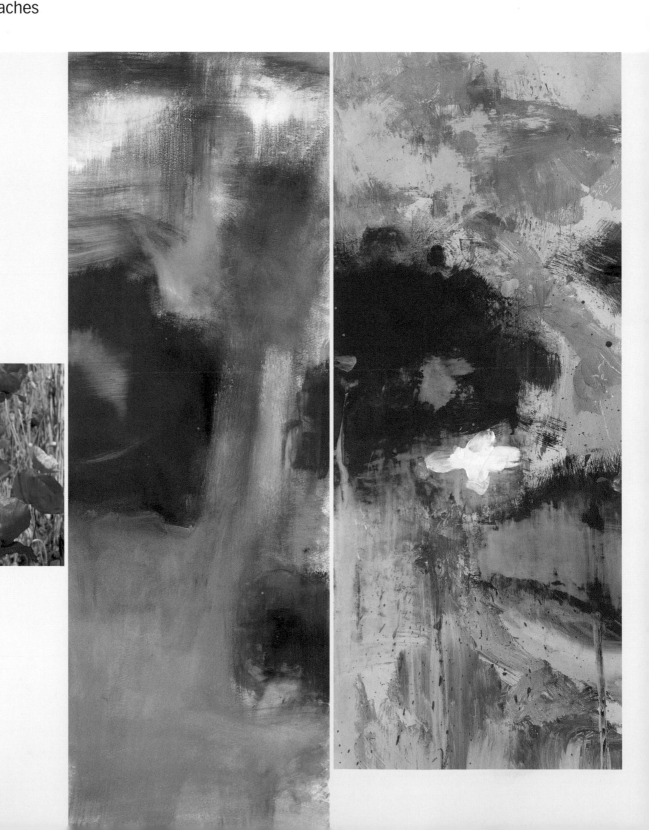

Another model Pursuing her interest in achieving a poetic and atmospheric feeling in a floral painting, Gemma Guasch has chosen some orchids as the model this time. This flower offers a range of delicate pastel colors with a sensual effect. The diagonal branch creates a very different composition than the poppies, giving the forms and the space a more empty, Zen-like feeling. The sfumato was created with sable brushes and wide badger hair brushes.

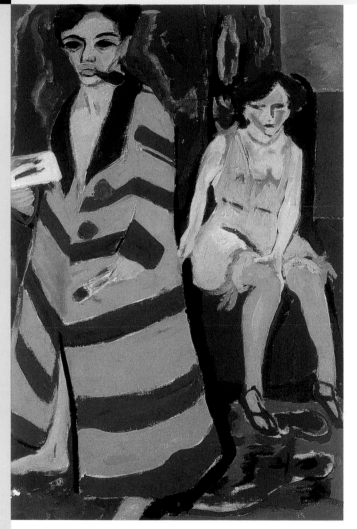

Ernst Ludwig Kirchner
Self Portrait with Model, 1910–1926
Hamburger Kunsthalle
(Hamburg, Germany)

At the beginning of the twentieth century, some painters in vanguard movements like Fauvism and Expressionism began painting with flat colors. This emphasized the two-dimensionality of the painting and rejected the "fiction painting" implicit in perspective and volume. Ernst Ludwig Kirchner (1880–1938) was one of the founding painters in 1905 of the German Expressionist group "Die Brücke." Based on post-Impressionism and Van Gogh, he and his friends created a flat painting style using pure colors, that was a parallel movement to the Fauvism movement in Paris. The Expressionists did not look favorably on Fauvism, which they found too balanced and decorative, an art they referred to as "merely agreeable." The Expressionists, on the other hand, defined themselves with a direct and lively painting style, with primitive colors, that strived for elemental sensations and didn't concede to the tastes of the time. As Kirchner said, "anyone who expresses himself directly and without disguise is one of ours." In Berlin, Kirchner found a theme that matched his restless and nervous temperament: the big city, where the human figure occupied practically the entirety of his work, except for some very interesting landscapes. In *Self Portrait with Model,* as in many of his paintings, the model symbolizes the muse and the art for which the artist abandoned his career as an architect; it stands for the bohemian lifestyle, transgression, and liberty.

03

Synthesizing a portrait using areas of flat color

In this project Josep Asunción has created a portrait of two adolescents with an esthetic similar to that of the two subjects of the portrait: a dynamic distortion, areas of flat color, and contrasting colors. Making this creative piece took a great effort to synthesize and simplify, using numerous studies of the faces to reduce their features and volumes to a few shapes in several gray tones based on the light. The work was done on unprimed pressed cardboard to accelerate the drying time of the paint and reduce blending between the colors.

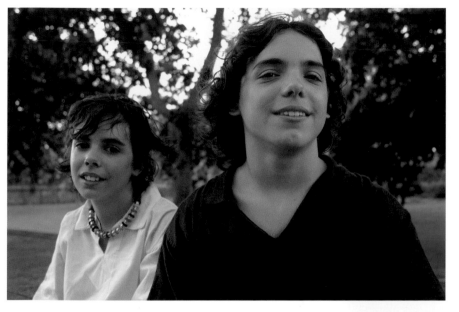

"Art is made by man. His own figure is the center of all art, since his form and his dimensions are the fundamental starting point for all types of sensations."

Ernst Ludwig Kirchner, *Personal Diary*, 1927.

Step-by-step creation

1. Based on the previous sketches and studies a very detailed drawing is made on the cardboard with pencils, outlining each area of light. The white areas define the areas with the most light and the black ones are the darkest areas. The intermediate areas logically correspond to medium tones of light.

2. The work is laid out in three general tones, a harmonic trio formed by violet as the dark color and yellow as the light one; green will be the middle tone. The violet is painted with a filbert bristle brush; the paint is a little diluted so it will penetrate the cardboard and not build up on the surface. The outlines are followed as closely as possible with the brush.

3. After all the darkest areas are painted one can easily see if the portrait is accurate. If it is not, there is time to correct any errors by adjusting the painted areas, enlarging them or seeing how they can be reduced by painting over them with the next color.

4. The artist moves on to the next tone in the light scale, the green. Since the work is done on unprimed cardboard, and the paint is slightly diluted with turpentine, it will quickly penetrate the fibers and drying will be accelerated. Care is taken not to paint outside of the drawing or to overlap the edges of the painted areas to avoid creating a third intermediate color.

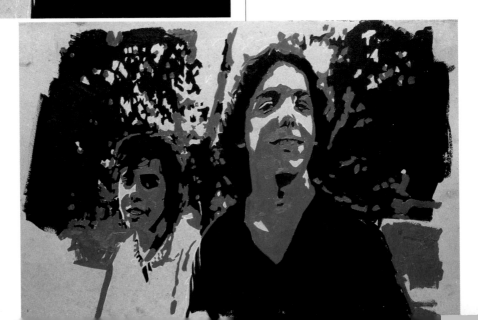

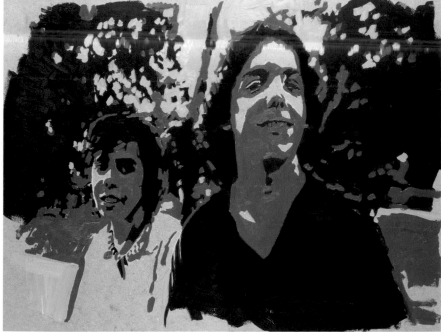

5. At this point of the work the yellow has been resolved in most of the areas of greatest light; a decision was made mid-painting to change the plan. These zones are divided into several colors that will enrich the final results.

6. The color of the cardboard is very appropriate for the light on the faces and imparts naturalness, so a decision was made not to paint over these areas. On the other hand, the girl's shirt and some parts of the background are painted an intense orange. This is a very bright and active color that creates a really dynamic chromatic contrast, a good finish for a portrait of children.

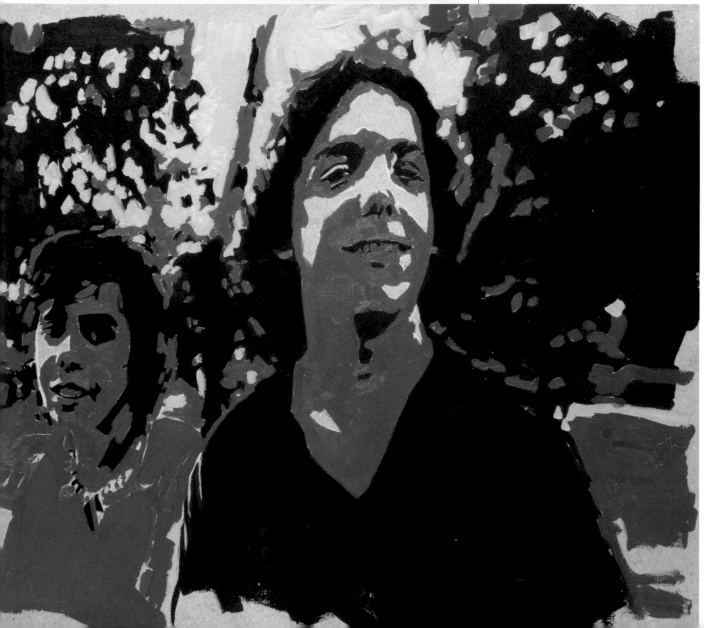

03 Gallery

Other versions

Using the same drawn pattern, the artist made more paintings on cardboard. In this gallery the different artistic effects that are created by modifying the number of colors as well as the range of colors can be appreciated.

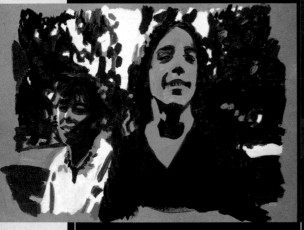

This painting is based on a monochromatic range of three values: white, black, and middle gray. The result is much like a newspaper photograph, although it is richer because of the textural qualities of both the oil paint and the pressed cardboard.

This is the most complex painting in the gallery. It has five values of light from white to dark blue in a melodic monochromatic range that is perfectly balanced. The finish is very elegant and it has a pronounced sense of unity with no contrast other than that of the light. The complexity of this work is found in the arrangement of the flat areas that imply a great effort made in arranging them on the picture plane.

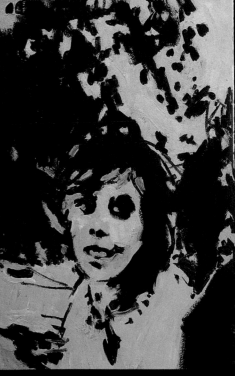

This work displays the greatest amount of synthesis. It only has two values, light and dark. Instead of depending on black and white, the artist preferred two warm tones, burnt sienna and Naples yellow, both slightly tinted, the former with red oxide and the latter with white. The final image is fresh and radical, without any medium tones, like the adolescence that is being illustrated.

Here the harmonic range consists of the classic trio of primary colors, tinted a little to personalize them more. The yellow is cadmium medium rather than lemon, the magenta is redder than normal, and the blue is indigo with a little carmine, much darker and more violet than the true primary. The chromatic contrast is deliberately intense and artificial.

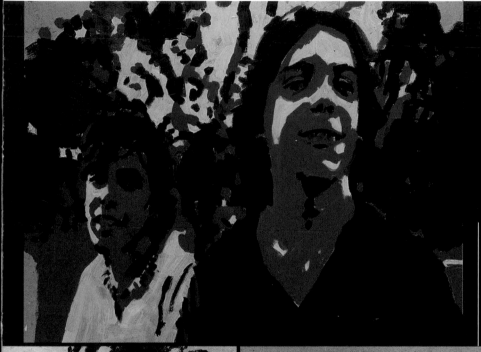

To experiment with a different applicator, the artist used a spatula instead of a brush. The result is more textured, but not any more contrasting or affected. With the gain in texture came a loss of precision, since it is very difficult to keep the paint within the outlines.

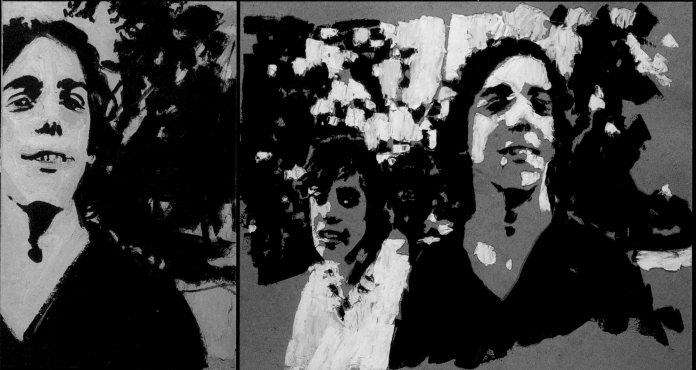

03 Window

New
approaches

Another point of view The whole project was done with very analytical, flat brushstrokes, with hard edges and a cool feeling, and without much emotion transmitted in the strokes. However, it is possible to make flat brushstrokes that are charged with feeling if the amount of paint is changed, and if we accept paint blending between each stroke as if we were looking at the painting through a glass window or translucent veil. The final effect is much more mysterious because the silhouette fades. The drawing of the models is less precise and blurry because the general and flat brushstrokes are also soft with imprecise edges.

Another model Continuing with the idea of treating the live model as a flat plane, Josep Asunción chose this time to paint a very suggestive and beautiful animal subject, focusing on the optical effect of the zebra's markings. The flat planes have been organized into three tones —black, white, and gray—and they have been applied with flat brushes that have been varied according to the precision required at that moment. The cardboard has greatly helped to accelerate the drying time of the paint and avoid undesired blending.

04 Textures
Creative approach

Many creative people have demonstrated interest in different disciplines; such is the case of the Swedish artist August Strindberg (1849–1912). He is better known for his talent as a dramatist, although he was also a photographer, alchemist, and painter. Since childhood Strindberg manifested an unbalanced personality, which caused him to have an unstable and painful emotional life, and this pain can be seen in his paintings. Contemplating his paintings one perceives loneliness, struggle, and existential angst in the heavy brushstrokes, loaded with thick paint. In general, his landscapes reflect his interior struggle and torment. According to Franz Kafka he earned his geniality "by his fists." He was a friend of Gauguin, Munch, and Nietzsche. He enjoyed their understanding, since his contemporaries did not recognize his talents because his work was too modern for its time. Today he is considered a precursor of the Abstract Expressionism, or Informalism, of the 1950s. His expressive strength can be seen in the painting *The City*, in his use of paint and the thick and unsettling strokes made with a spatula, which reflect a melancholy view of life.

August Strindberg
The City, 1903
National Museum
(Stockholm, Sweden)

Texturing the material to give density and body to the landscape

The landscape is an ideal subject for experimenting with mixing fillers and pastes with paint. The artist for this project, Gemma Guasch, has been able to express the different elements that make up this landscape through these materials. The oil was mixed with marble sand, and large quantities of it were deposited on a pressed cardboard that was first primed with gesso. The silky texture of the oil was thus changed to create new possibilities that were more dynamic and expressive. Spatulas, scrapers, wide paintbrushes, and hog bristle brushes are the tools that were used for this work.

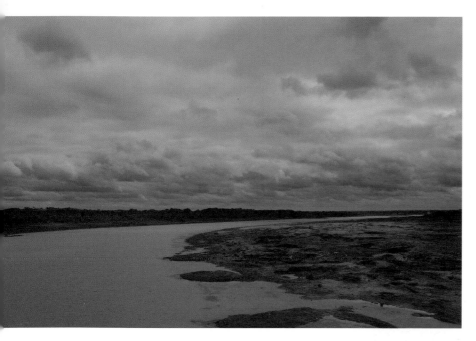

"*It turns out that the material that we all work with is the same. It is a material in which one does not know what he is going to find, a dark material. From this one makes something with the instruments of each particular art form.*"

José Ángel Valente, *Communication on the mural, Conversation between Antoni Tàpies and José Ángel Valente,* Autumn 1995.

Step-by-step creation

1. The landscape is laid out on white gesso primer, defining three large areas: sky, land, and water. A thin base of blue paint very diluted with turpentine is applied with a wide brush. The paint is spread without leaving many marks with the help of a rag to soften the surface and create large areas of color.

2. After the composition is defined, a textured base is created. The paint is mixed with marble sand, impasto medium, and essence of turpentine in a bowl and then poured on the support. We work on a table, horizontally, spreading the mass with a wide scraper. We do this three times, varying the color: blue for the sky and water, and ochre and black for the land.

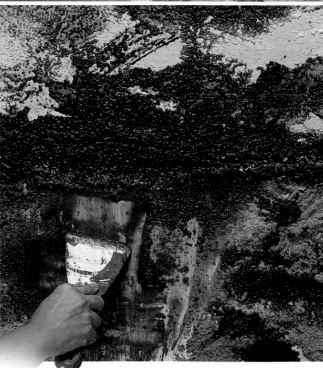

3. Using scraper and spatula we make wide dynamic strokes of black paint mixed with marble sand and essence of turpentine. In the sky the strokes do not cover the blue background to highlight the depth and not lose any light. Larger quantities of material have been deposited on the land but they have not been spread so they will look more solid and stable. The water is worked with more diluent, spreading the material with the scraper to open grayish grooves that evoke the liquid texture of this element.

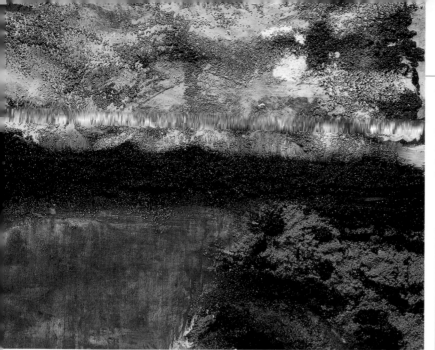

4. After waiting some time for this to dry, two days at least, painting continues without fillers, indicating the light areas in the sky with light gray applied with a wide brush, then a thin coat of the same is also spread over the rest of the landscape, except for the ochre of the land, to soften the hard and rough textures a little.

5. To finish, a bluish tone is added to the water and part of the sky to bring in new touches of color and texture. Some burnt sienna is applied to the land, which balances the blacks with more light and freshness. In the sky, thin coats of white are applied to add light and depth. The final result is solid and intense, but less arid and dramatic.

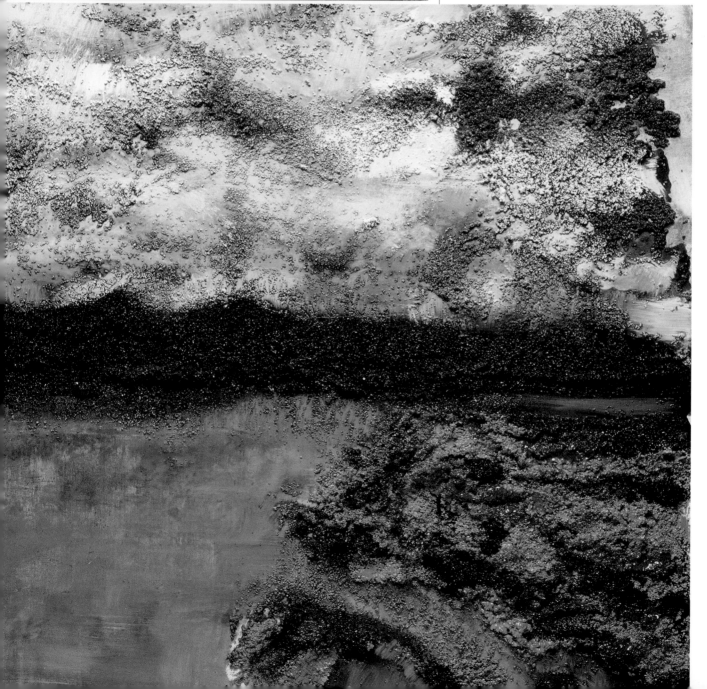

Creative techniques **oil**

04 Gallery

Other versions

Aiming to create a rich and varied gallery, the artist mixed the paint with different fillers and pastes. River sand, marble dust, straw, and relief medium have all modified the silky texture of the oil paint and given it new tactile sensations. All the works were done on pressed cardboard primed with gesso.

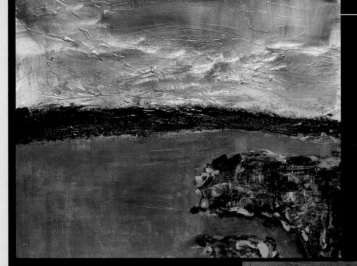

The textured base of this painting was created with acrylic relief medium. After the base was dry the land was created with a mixture of impasto medium, oil paint, and essence of turpentine. The sky was painted in two ways; first the lines with a dry wide brush, and then the colors with a rag to create atmosphere. For the water the artist worked wet on wet, which favors transparency. To finish, a bit of light was added to the land with oxide yellow applied directly from the paint tube.

In this work the paint was mixed with marble dust and spread over the support to give it an overall grainy and elastic texture. Then, the land was painted with a heavy impasto of paint and filler, applied with a spatula in different earth tones, trying to spread the paint without mixing it together. To represent the water, the first layer of the base was just tinted with a very wide brush. To finish, some strokes were applied directly to the sky, increasing the darkness with heavily contrasting impastos.

Varnishes offer, among other things, the opportunity to work with a shiny and hard look material. Here a landscape is laid out with paint heavily diluted with essence of turpentine and spread with a sponge so no marks would be left on the surface. Then some areas were darkened using cherry furniture varnish. This began with a thin, transparent overall coat then more was poured on the areas of land to create relief, opacity, and hardness. The final patina ages the landscape and bathes it in darkened tones that give it a nostalgic feeling.

This is the most creative work in the gallery. First straw was glued to the support with vinyl glue to define the land, not touching the other areas, and was left to dry for an entire day. Then, to create more contrast with the hardness of the chosen texture, work was done in a very liquid manner; in the sky a few brushstrokes were made with a wide brush, and paint was dripped in the water and the excess liquid was absorbed with a rag. All this was done with warm grays that were blended, while allowing the straw filler to be the protagonist of the piece.

In this piece the paint was mixed with river sand to create a rough and hard effect. This time no base coat was used; the mixture was applied directly to the different parts of the landscape. The land was made with heavy contrasting impastos that were laid on with a scraper but not further manipulated. In the sky the rough feeling of the sand was increased by using less paint and a dry brush. The water was painted with dark colors that are very dense and opaque.

04 Window

New approaches

Another point of view Up until now, the textures were made using fillers and paste to create density and thickness. In this case, a textural effect that is light and transparent was chosen. A very large watercolor paper, high quality and with a heavy grain was used for the support. The landscape was made by first applying very diluted oil and varnishes, and then powdered pigments. The varnish was spread without trying to cover everything, and the paper shows through in some areas. The pigment was applied while the varnish was still wet, using two methods. It was blown directly on the surface with a pulverizer where it stuck to the varnish and sometimes formed small lumps; in the more ethereal zones of sky and water it was applied with a wide dry brush to create a pleasant atmospheric effect.

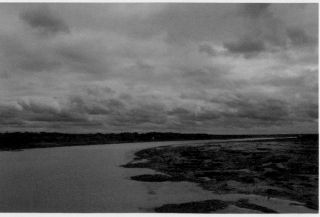

Another model Here Gemma Guasch, using marble sand and oil paint, has re-created the textural and material sensations of some rice paddies that caught her attention during a trip through the north of India. The landscape has a simple perspective and a soft, warm light, depicting a sweet, attractive, and man-made natural scene. The filler was applied in an overall manner, strengthening the land's surface density while maintaining the clear, clean light. The final result holds fresh areas of dense paint bathed in the clear light of day.

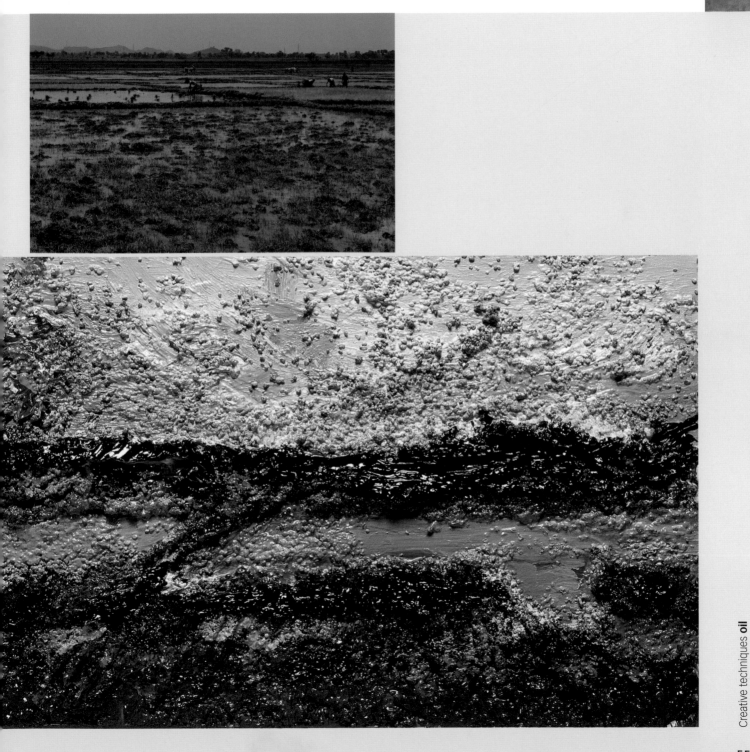

05 Glazing
Creative approach

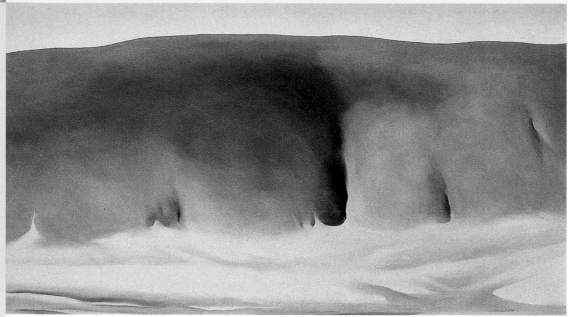

Georgia O'Keeffe
The Black Place,
1943
Art Institute of
Chicago

A pleasant and aesthetic view of the world around us is part of what we see in the work of Georgia O'Keeffe (1887–1986). She spent half of her life painting in the New Mexico desert, which she loved for its nature and light. She painted tirelessly until she lost her sight in 1972. Her husband, the photographer and gallery owner Alfred Stieglitz, encouraged the diffusion and knowledge of her work, a situation that was somewhat unusual for a woman of her era. Nature was the source of her inspiration. She caught it on her canvas with wavy lines, subtle gradations, and elegant transparencies. Her works show us a personal, intimate, and free vision that falls between abstraction and realism. *The Black Place* was her mountains, which she painted many times. She depicted them with simplicity and in her hands they became highly stylized. She painted them with thin layers of color, creating exquisite glazing. Georgia O'Keeffe transformed the desert into a paradise where we can enjoy a pleasant and sensual view.

Representing the subtlety of cloudy peaks by glazing

The mountains of Manalí, at a height of over 6,000 feet in the Himalayan range, were the inspiration for this project by Gemma Guasch. The foggy whiteness that intermittently and dynamically bathes the mountains requires the work to be created using transparency and glazing techniques. The support chosen for this project was a primed canvas of mixed cotton and linen. The oil paint was mixed with different additives to make it possible to create thin layers of subtly shaded colors. The applicators were sponges, rags, rollers, and soft brushes. The monochromatic color range was made with Van Dyck brown.

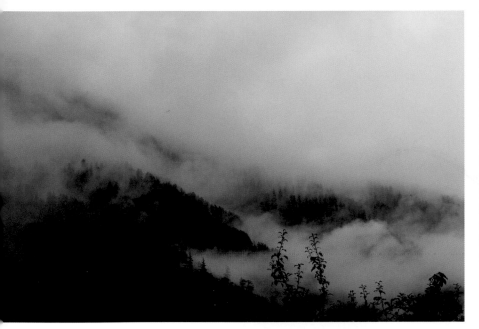

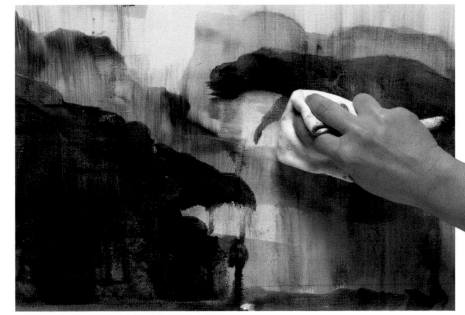

"The ability to simplify means to eliminate the unnecessary so that the necessary may speak."

Hans Hoffman

Step-by-step creation

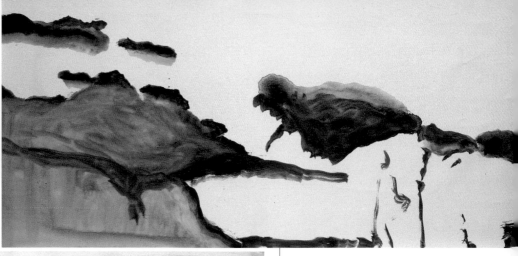

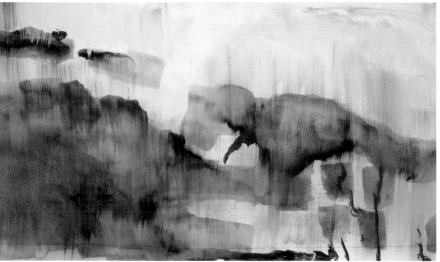

1. Begin the work by painting in the visible parts of the mountain, leaving the rest of the canvas untouched. This is done with Van Dyck brown as the base color, applied with a damp sponge. The paint was diluted with essence of turpentine to help it spread and dry quickly.

2. Next, use a foam roller to spread the paint that has already been applied across the entire picture. The color is thinned to create a glazed effect. The roller is moved carefully in an up and down motion to create an unfocused view of the landscape.

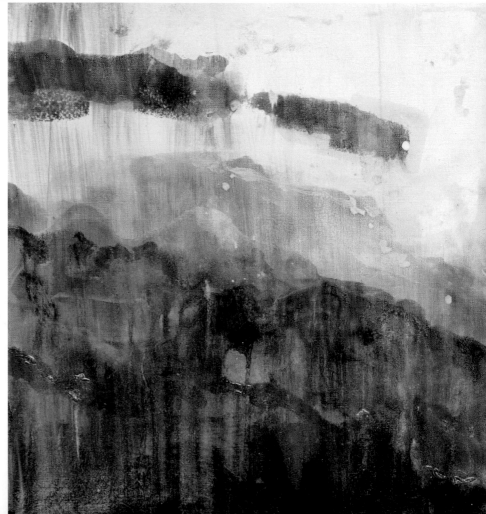

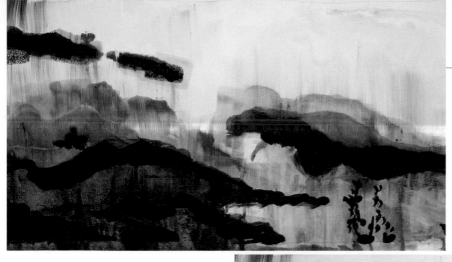

3. Glaze requires working with layers of paint that are thin, transparent, and overlaid. It is a common error to think that the colors should not be contrasting. At this moment contrast is created by marking the dark outlines in relief with some wide strokes of paint mixed with linseed oil and impasto medium.

4. The last application of paint must have time to dry before proceeding; in this case the impasto medium accelerates the drying time. Later, work begins with the glazes, starting by spreading some of the dark color that was applied earlier. To do this, the painting is placed in a vertical position. The canvas is held with one hand and with the other the mixture is applied directly, creating an irregular curtain that is darker and has several shades.

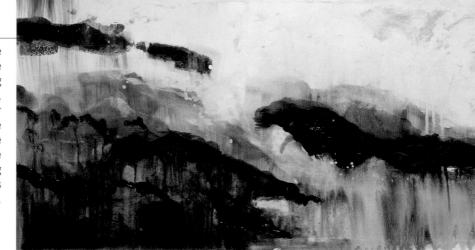

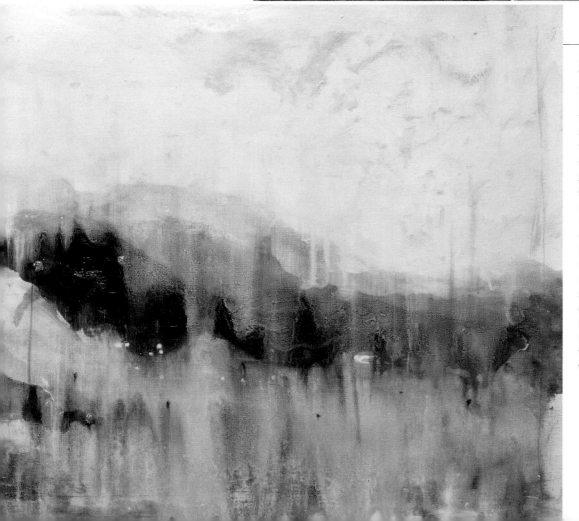

5. To finish the work white glazes are created that allow the landscape to show through. These glazes are applied only after the painting is completely dry; it is a good idea to wait an entire day. The canvas is placed in a horizontal position to better control the amount of paint and keep it from running; then the color is applied with a sponge. Finally, the canvas is tipped up a little so the paint can run and partially cover the mountains with white.

Creative techniques **oil**

05 Gallery

Other versions

Working with glazes opens up a very beautiful world. They are created with many ingredients: oils, mediums, and essences. Mixed or used alone, they offer limitless possibilities. This interesting gallery shows the effects that can be achieved using a variety of supports and surface preparations.

This work was done on unprimed linen. Raw linen absorbs a lot of color and favors transparency where its fabric and natural color can be seen. Lines and brushstrokes dry very quickly and are more clearly seen. The glazes were made with a mixture of paint with walnut oil thinned with essence of turpentine, and they were applied with a sponge and a synthetic brush. The result is clear and elegant.

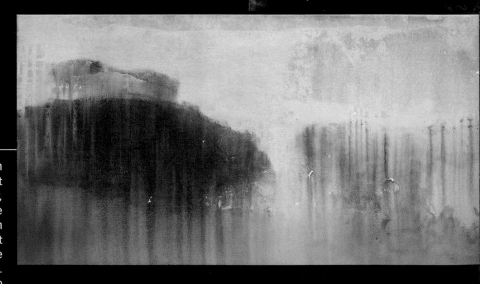

These more daring glazes were made on a linen canvas primed with transparent glue. They were created layer by layer, slowly arriving at the desired tone. The paint was mixed with stand oil, which speeded drying time of the layers without losing elasticity. The final glaze was done on wet paint with essence of turpentine. The wet on wet glaze caused the paint to run and create a very poetic image.

Here, the canvas was jute, chosen for its rigidity and strong texture. The glazes are blurry and show marked edges. The paint was mixed with Venetian medium, which speeds up drying and thickens the paint, making it more matte. The result is a landscape with hard and dense fog.

This work was done on primed cotton canvas. The fabric was first dampened with pure linseed oil; then it was worked directly, adding paint without waiting for it to dry. This paint was diluted with linseed oil mixed with essence of turpentine. The fusion of the oily brushstrokes over the wet and oily base caused the strokes to mix in a loose way. The result is very suggestive, a landscape that breathes freshness and liberty.

The unprimed cotton used for this work caused rapid absorbing and immediate drying, while at the same time increased the transparent effects. The inconvenience of unprimed fabric is that it is not protected, so it's best not to make heavy use of oily substances. The paint was mixed with painting medium to make it more balanced. The mixture was poured on the horizontal canvas and spread with a rag, allowing the support to absorb the paint and facilitate transparency. The resulting work stands out for the darkness and lightness of the mountains.

05 Window

New
approaches

Another view To achieve a different view without losing suggestiveness the color palette was modified. Here the dark brown and gray tones are left aside for a range of bright and dark blues. Three distinct blues were painted on a stiff jute canvas: Prussian blue to represent the hard edges and parts that will not be covered by fog, cyan blue thinned with essence of turpentine for the sky, and ultramarine blue mixed with medium and essence of turpentine to represent the fog. The application of the color adds freshness and fantasy to the piece.

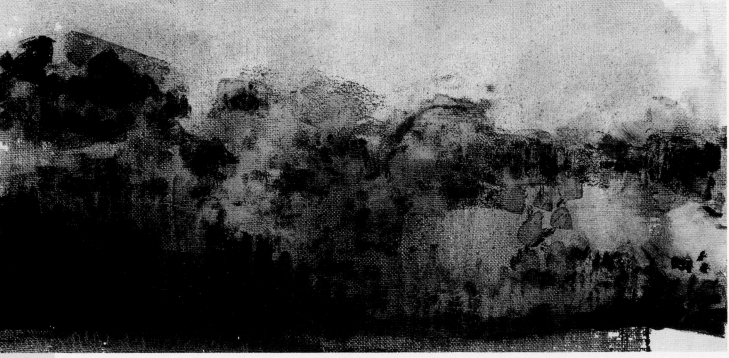

Another model This time the artist offers an urban landscape. This is a view of the city of Varanasi in India. The photograph was taken through a window with rain on it, which inspires creating a work with thin, transparent, and subtly gradated layers. A canvas with a linen and cotton mixture was chosen, and the paint is oil mixed with Liquin. The applicators are wide synthetic brushes, a roller, and a sponge. These all helped create an artistic interpretation that is more poetic than descriptive.

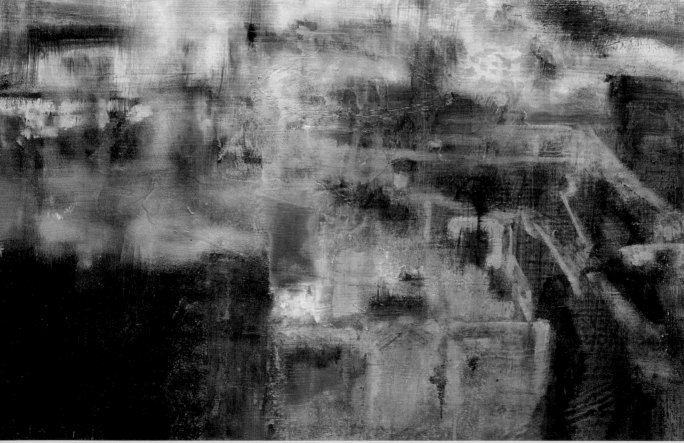

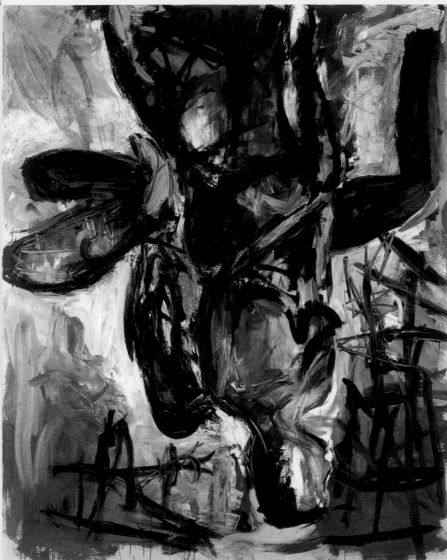

A new current of expression took hold in Europe and on the American continent after the Second World War. During this time Georg Baselitz (born 1938) upheld the value of gesture painting. Savagism, irrationality, even "bad painting" are some of the names used to define the new German gesture painting of the second half of the twentieth century, of which Baselitz was a pioneer. In 1961, along with his friend painter Eugen Schönebeck, he announced the birth of a new movement, Pathetic Realism. This consisted of violent works that attempted to satirize the pride and Puritanism in Germany at that time. Starting in 1968 the artist decided to turn his paintings upside down to highlight aspects like light, color, and material, leaving the subject as secondary and causing a perceptual lack of comfort in the viewer. His contrasting brushstrokes—rough, direct, even crude—were a great influence on the neo-Expressionist painters that followed him.

Georg Baselitz
Elke V, 1976
Private collection

Representing the human figure with dynamic brushstrokes

Excited about exploiting the expressive potential of a loose and vigorous brushstroke, Josep Asunción approaches the subject of a nude with a series of *alla prima* sketches on handmade rag paper. Changing the applicator, the speed, and the amount of paint, he explores a variety of strokes and achieves fresh and strong results without losing the strength of the figure. Oil paint allows flowing, fresh, and direct gestures, as long as the strokes are not repeated so many times that the paint mixes too much.

"*The work of art becomes real in the mind of the artist, and it stays in the mind of the artist.*"

Georg Baselitz.

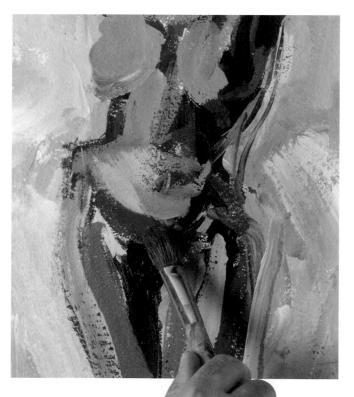

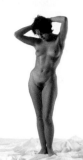

Step-by-step creation

1. The silhouette of the figure is drawn directly with a fine round brush. To center it well on the paper an imaginary line is used to represent the spinal column and the curve of the waist. The center of the paper coincides with the visual center of the figure, located in the abdomen. The twisting of the head is defined with a small cross that forms the eyebrows and nose. Using these axes, it is easier to define the torso and extremities.

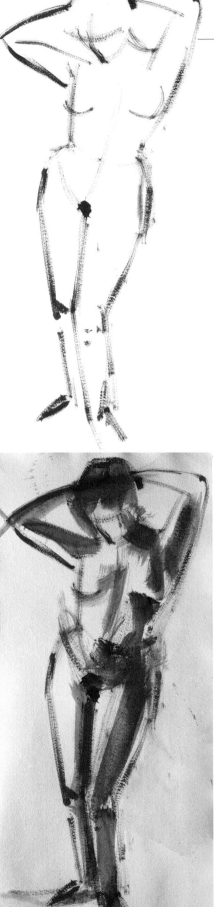

2. Using a larger flat brush and paint diluted with a little essence of turpentine, shadows are placed on the body to indicate its volume. They should be direct strokes, made with a single pass so as not to lose the sense of speed and the texture. We accept the splashes that are naturally created by the paint in the brush and the speed.

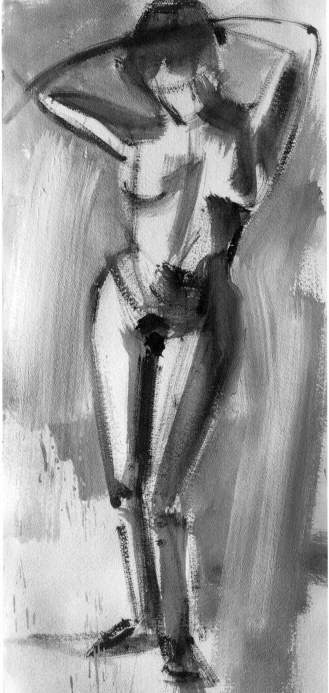

3. Next, the background is colored to separate the figure from it and give it some presence. These are abstract strokes that suggest the presence of space behind the model. Because of the narrow format the decision is made not to imagine objects and details, which would overcrowd the space.

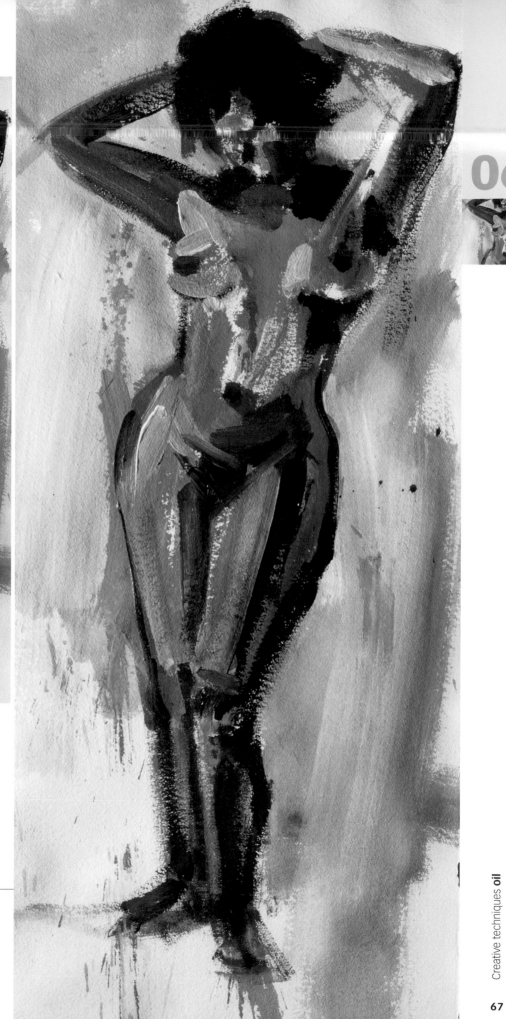

4. The impact of the light on the model is quite harsh, so the representation requires some contrast. For this reason, this time around the shadows are strengthened; this dramatizes the sketch and relates it to the Expressionism that inspired this work.

5. Since the sketch has excessive contrast and lacks body, new, heavy strokes of undiluted pink and gray paint are applied. This gives the final work a sense of body and matter.

Creative techniques **oil**

The final results of these sketches vary according to the applicator that was used. Each choice affects the amount of paint that will be applied, and the speed of application, which provokes splashes, drips, blurred edges, and distinct textures.

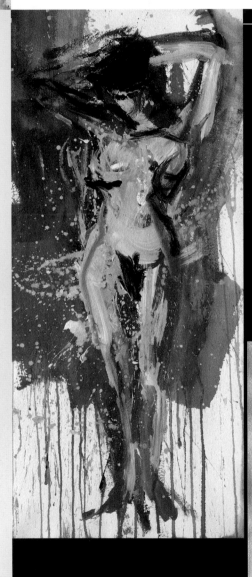

This sketch is based on some very diluted brushstrokes made with a full wide brush that caused splashing and running paint. Then very quick lines were made with a medium round bristle brush, without too much worry about precision and details.

To create this work, which is more soft and contained than the others, it was decided to work with a dry brush, without diluting the paint at all, to create a rough and blurry appearance. To complete the sketch, it was lightly wiped with a rag to increase the blurred, atmospheric effect.

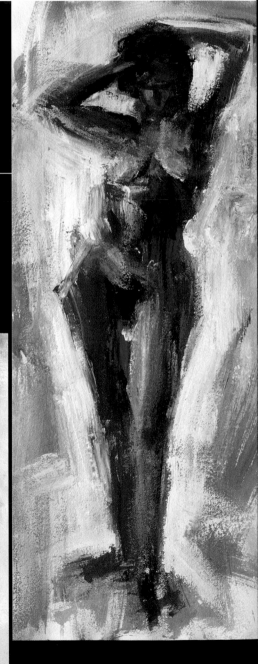

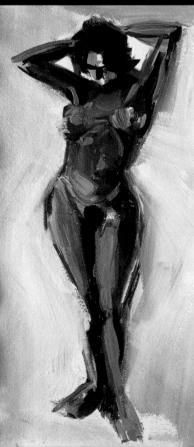

In this sketch a round sable brush was used. The softness of the brush and the viscosity of the paint, slightly diluted with stand oil, are the determining factors that resulted in fluid brushstrokes and the soft blending that model the nude.

This *alla prima* sketch made with a spatula is a perfect mix of tradition and modernity. The spatula is not precise, which obliges one to carefully decide which direction each stroke should go; however, marvelous textural effects can be created by dragging the paint.

Here is a good example of digital painting, that is to say, a painting done with fingers. Lines and marks of different kinds are made depending on whether more or less paint is used and whether it is thick or light. One can also play with the size of the line by using different parts of the hand, like the thumb, pinky, the palm, and the side.

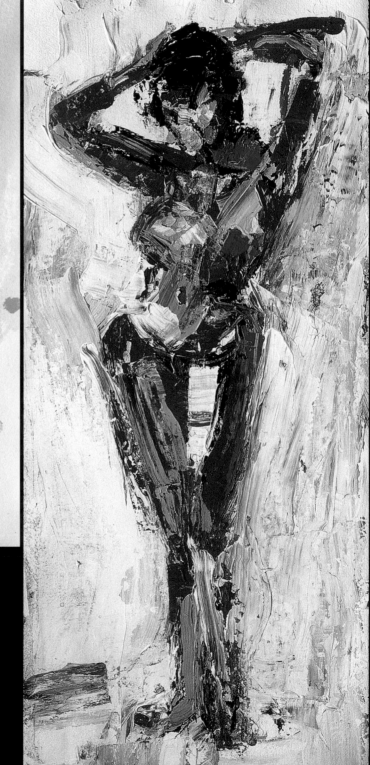

06 Window

New approaches

Another view Another way to approach the same subject with gesture painting is based on a contained and poetic point of view. In it, two kinds of expressionism are recognized: dramatic and lyric. In the first group are strong gestures, overflowing energy, and often violence.

In the second group, as shown in these two works, there are fewer brushstrokes, the energy is more contained, and there is a controlled tension. What is a scream in dramatic Expressionism is silence in lyric Expressionism. What was overt is suggestive here. What was depicted as pain, here is perceived as sensuality. The road to this gestural lyricism is economy of intervention—a few brushstrokes with just the right amount of tension.

Another model Along the same lines as the sketches of a female nude, the artist decided to repeat the experience with a male model, to try his brushstroke gestures in oil based on a more muscled anatomy. He has used wide flat brushes to create short strokes and large blended areas. The paint, mixed with small drops of stand oil, is slightly viscous, which favors blending without excessive blurring that would soften the definition of the musculature of the male body.

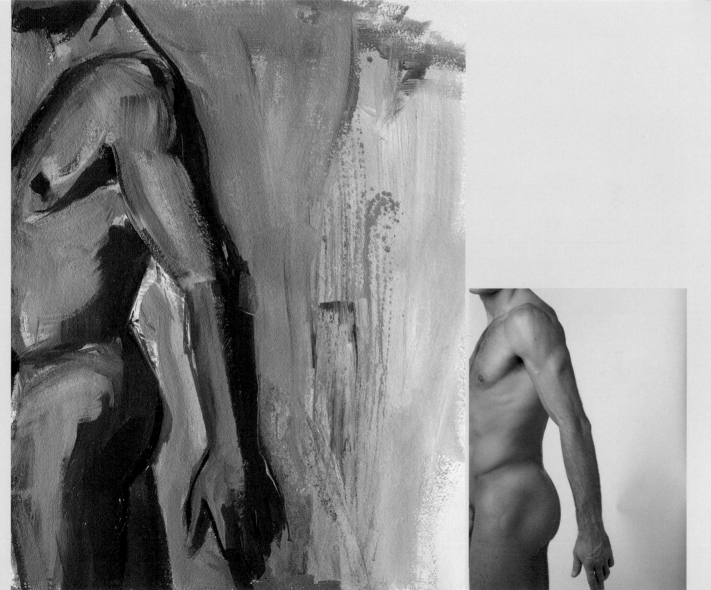

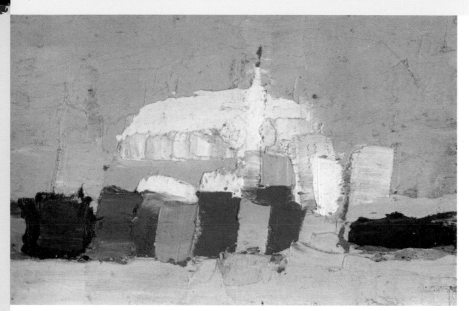

Nicolas de Staël
Le Lavandou, 1952
Private collection

Nicolas de Staël (1914–1955) is one of the most representative painters of the twentieth century when it comes to oil impasto. His landscapes are simple areas of color that indicate the distance between objects, masses, and empty space. He usually applies the technique of juxtaposed planes made with a spatula and a lot of paint, playing with the thickness and the edges of the outlines. Nature, represented in this way, takes on the aspect of a wall where color is retained and perceived as a solid and palpable body in its relief. During the spring of 1952, Nicolas de Staël was on the French Cote d'Azur and made 40 small-format paintings illustrating his fascination with the blinding light of the beaches of Lavandou, a light he defined as "a Greek light, that only stones and marble can withstand" and with a "literally devoured" color. This series stands out as a rarity in this stage of the 1950s, which was dominated by geometric abstraction and large formats.

Dense color in a Nordic landscape

Inspired by the qualities of paint in the impressive body of work by Nicolas de Staël, Josep Asunción now approaches a creative experiment using the oil technique known as impasto. It is based on a Nordic landscape during a long August dusk: cloudy sky, dense forests on an island, and a house with its dock on the sea. Using brushes and spatulas, the artist creates thick strokes of impasto paint; the final result is very physical because of the relief caused by the large amount of paint that he used.

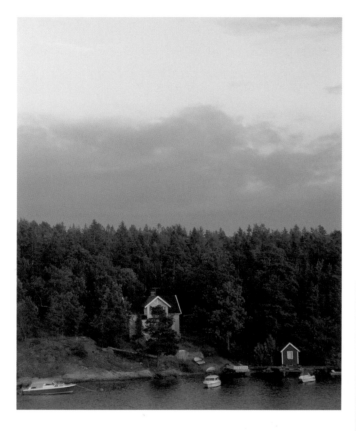

"Painting should not be just a wall over another wall. Painting should be part of space. I do not see abstract painting opposed to figurative painting. A painting should be abstract and figurative at the same time. Abstract because it is flat, figurative because it represents space."

Nicolas de Staël,
Témoignages pour l'art abstrait. París, 1952.

Step-by-step creation

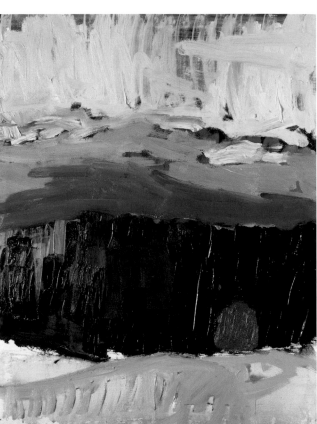

1. The composition is divided into three areas with a hog bristle brush full of diluted oil paint: the sky (which will occupy the upper half of the surface), the forest, and the sea (which equally share the bottom half). The house and dock are placed in the forest, adjusting their proportion to each other.

2. Painting of each of the areas begins. Unlike in other techniques, the brush is loaded with the correct color or color mixtures, because it would be more difficult to correct the colors later on the canvas.

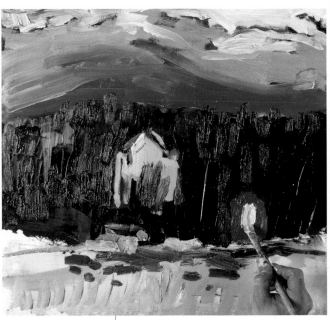

3. The interventions with a spatula are saved for the end, when there is quite a bit of paint on the surface. First each form and color is put in place, directing the brushstrokes without pushing too hard on the paint so as not to mix the colors and make the painting gray.

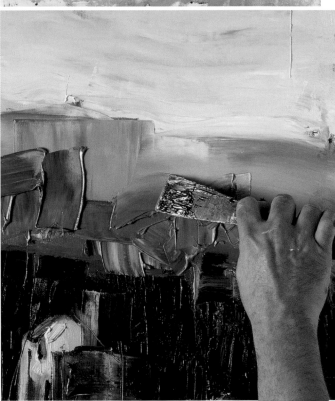

4. The impasto is created in small dabs with a medium steel scraper to control the strokes. Try not to go over the same area too many times to maintain the color and create streaks and color gradations.

5. A wide steel scraper is used to take a different approach, dragging the paint. Dragging creates light gradations and threads of color within the stroke. It is best not to go over the strokes, since each time effects and colors will be lost.

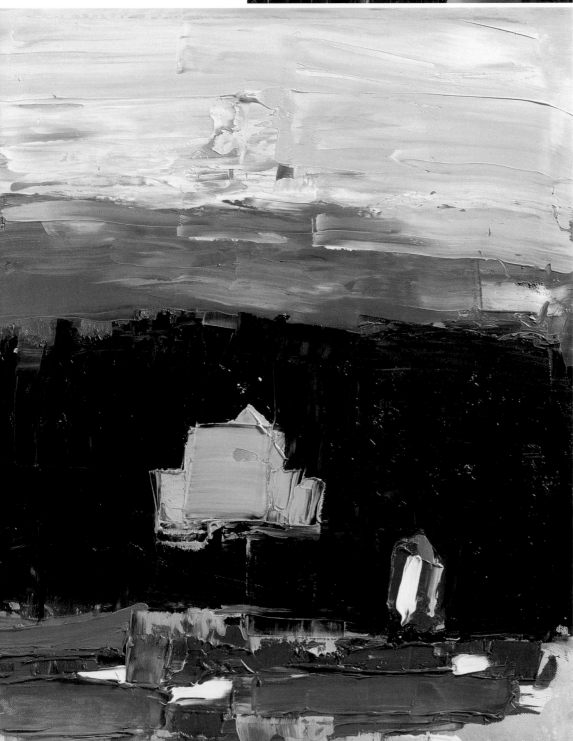

6. The final result is a combination of strokes of different sizes and colors. The impastos and dragging made with the flat scraper have created mixes and streaks with great textural qualities, and an attractive effect of thick paint.

Oil impastos can be made with very different effects depending on the applicator used: spatulas, brushes, rags, and fingers. In addition, there is a wide variety of brushes and spatulas with different composition, sizes, and shapes. The direction of the stroke, its precision, and the amount of paint can also be varied. This gallery shows some variations created by the artist.

This work was finished by pressing it with the tip of a small spatula. The effect is rough and imprecise. The touches do not create clear areas of color, but textured ones with colors that are not uniform, giving the painting drama and atmosphere.

Based on the dragging technique, the image has been stylized by reducing the landscape to three bands of color: sky, forest, sea, and two colors for the buildings. Textures are created according to the amount of pressure that is applied. The final result is somewhere between figurative and geometric abstraction, in the style of Nicolas de Staël.

The landscape has been developed using impastos of parallel vertical lines made with a hog bristle brush loaded with paint, and a thin spatula. The work was finished by scraping some areas with a toothed spatula to create vertical lines.

Paint laden brushstrokes are the most traditional way of doing impasto. They must be sure and calculated, and applied without moving the brush, unless you wish to mix the paint on the canvas. Sometimes it is necessary to allow the work to rest for several sessions so the paint can dry a little and not muddy the tones.

07

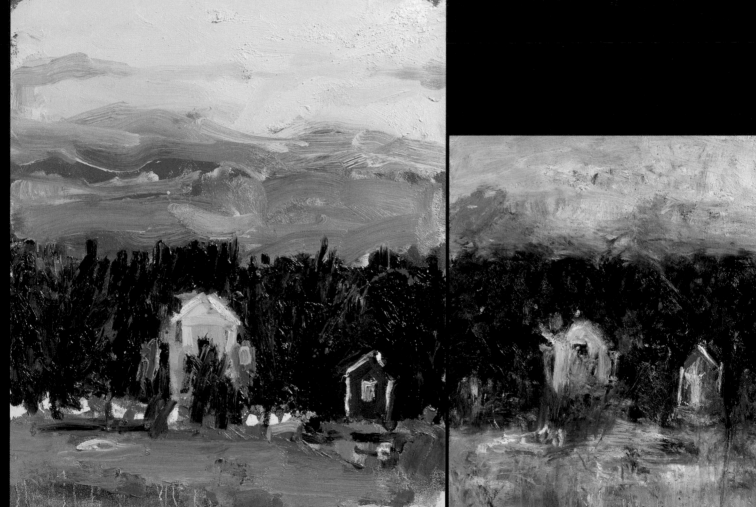

Impasto effects can also be created with a rag. To do this, first paint with a brush or spatula and a lot of paint; then use the rag, striking or dragging it in the paint. The result will be blurry and out of focus. This technique runs the risk of excessively muddying the picture if the number and intensity of the applications are not controlled.

07 Window

New approaches

Another view Without changing the model or the format, Josep Asunción wanted to create a very different view of the same picture. He decided to use a more expressive and free color range; the neutral colors of the Nordic landscape are now extreme. In addition, to distance himself from the original realism the artist has stylized the forms as flat shapes, taking the painting closer to geometric abstraction.

Another model The artist has directed his attention to a new landscape subject that is more structured and architectural. Applying the same impastos and spatula dragging demonstrated in the step-by-step, he has been able to create a textural effect for each element of the landscape. It is worth pointing out the added brushwork and scraping effects in some architectural details and in the human figure.

08 Optical Mixing
Creative approach

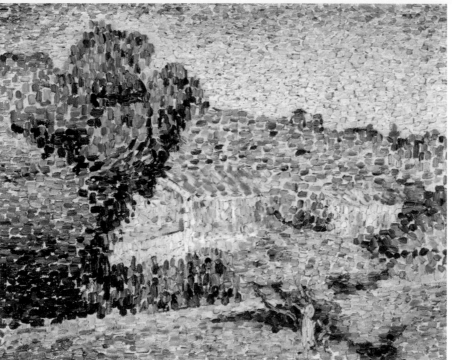

Cross,
The Pink House,
1901–1905
Oil on canvas
15 x 18¼ inches
(38.5 x 46.5 cm)
(Brussels, Belgium)

At the end of the nineteenth century a very interesting post-Impressionist movement appeared that is known as Pointillism or Divisionist Painting. This painting is based on the retinal mixing of color, discovered by the geologist Bezold: if pure colors are applied directly to the canvas in small strokes, they will be mixed in the eye of the viewer and maintain all their natural luminosity, without becoming muddied as often happens on the palette. The artist Henri-Edmond Cross (1856–1910) was a great proponent of this movement along with Georges Seurat, the master of Pointillism, and Paul Signac, his Divisionist comrade who helped him notably advance the technique. From the middle of the 1890s, Signac and Cross abandoned the diminutive colored dots for wider and more ordered brushstrokes, similar to mosaic tessera, and they cultivated more daring color schemes, creating the so-called "second generation of neo-Impressionism," of which *The Pink House* is a clear example. The brilliant and luminous colors of this new Divisionism would later influence the Fauve painters and the Expressionists.

The expressive possibilities of Divisionist painting

The first Divisionist painters applied this technique in a very cold and analytical manner, mainly investigating how to decompose each color and then recompose it in the retina of the viewer. However, Cross, Signac, and some Fauvists like Derain and Vlaminck dared to use it more freely for lines and color. In this approach, Josep Asunción wished to follow an intuitive creative impulse, based more on brushstrokes than on color. It is a series of paintings on paper done outdoors, facing Santa Barbara mountain in Spain's Horta de San Joan, a mountain that protects the convent of San Salvador, which also fascinated Picasso at the beginning of the twentieth century.

"Through optical mixing (mixing in the eye of the viewer) of these pure colors, whose relationship to one another can be varied at will, one can achieve infinite shades, from the brightest to the most gray. Each brushstroke that is taken in a pure state from the palette remains in a pure state on the canvas."

Paul Signac

Step-by-step creation

1. Begin the work by making a detailed drawing of the mountain with a medium hard pencil. Since some parts of the drawing will be left visible, try to make sure that some of the areas are finished and the relief depicted well.

2. Color backgrounds are created for the sky and the farthest mountains; the foreground is left white for the mountain. To create a more intense color vibration, the background of the sky is painted red; this way it will vibrate with the later second coat of touches of blue. The paint is slightly diluted with turpentine to encourage absorption and drying.

3. Painting continues with diluted paint, the most important parts of the main subject. Three basic tones are used: white for the highlights, pink for the base of the mountain, and raw umber for the shadows of the peaks. In these areas the brushstrokes should be loose. Use a medium flat, sable hair brush.

4. Additional strokes of denser paint in burnt sienna and sap green are added over the previous base. This is a matter of creating more contrast and accentuating the relief and is used to create various effects, more or less thick, allowing the underlying color to show through.

5. To finish, some strokes of cool colors are added with sable brushes of various sizes and shapes, mainly medium flats and small filberts. The paint is now creamy and applied in small touches, avoiding any mixing on the paper. Some of the backgrounds are left uncovered so that their colors will interact with these final brushstrokes by mixing in our retina. A written notation reminds us of this place where the artist enjoys painting in the open air.

08 Gallery

Other versions

By combining different brushes over backgrounds with more or less paint, the artist has been able to create a wide range of results, some more atmospheric, others more conceptual. In all of the paintings in this gallery the mountain proclaims its presence and majesty. The writing forms part of the work, like an artistic element of equal importance to the rest.

This sketch with three representations of the mountain is a first approach to the subject. They are the first studies made of the silhouette, mass, relief, color—a point of contact with information that will help describe the object that is to be represented.

A fan brush was used in this work painted on handmade Oriental paper. This is a very interesting brush that creates open and transparent brushstrokes that leave a series of fine lines. The paint should be applied more liquid than dense, since the brush is very wide but has little hair. Although this is an oil painting, it looks like an Oriental watercolor.

Here the artist recycled a piece of paper with a pink background that was prepared for another project but never used. He partially painted the background, leaving a large area uncovered. He applied small dabs of flat paint and dry graphite and white chalk lines for the drawing and the written notation.

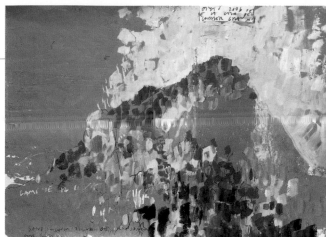

The Divisionist method was applied on a yellow paper using a round hog bristle brush with a little thick paint. The result of this dry on dry technique is rough and blurred, imprecise but also atmospheric, as if the air was full of humidity or steam.

This is the most impressionist work of the gallery, the most analytical and realist. It is a detailed study of the relief of a landscape, without altering at all the colors perceived by the artist at that hour of the day. It is a good idea to begin with versions like this one and slowly free up your creativity.

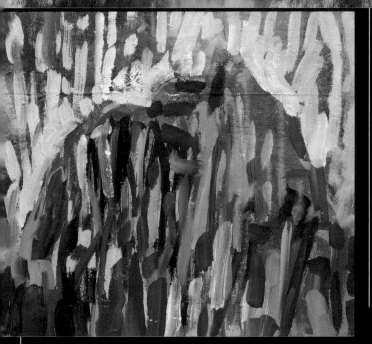

The focus of this painting is very different. The artist started with a uniform red background and worked directly with long alternating brushstrokes that blend in the viewer's eye. The format of the work is small, but the brushstrokes occupy the entire plane.

08 Window

New approaches

Another version Conscious of the fact that we live in a computerized culture, the artist asked himself how the Pointillists would have painted had they lived in our time. The answer is very easy—they would exploit the possibilities of the pixel. In this work, Josep Asunción reduced the resolution of a digital photograph of the same landscape until it was limited to a few pixels that show the real colors well. Next, he translated each different color, pixel by pixel, to a small dab of oil color. The result is a mixture of analytic image and poetic work of art. The grid background helps negate the expressive value of the brushstroke and reinforces the sense of a luminous, immaterial image. Like the works of the first Pointillists it is a patient study of light and color. Making such a work is a slow process that requires patience and observation, but the result is worth the trouble.

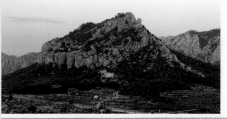

Another model Divisionist painting historically focused on two main themes, the landscape and the figure. In this window to new approaches, the artist wanted to begin a new path of experimentation using a nude. Normally, the human body would be treated like a volume rather than a space, but Divisionism allows for the creation of interesting plays of volume and space. It is a matter of working with the outlines, the folds of the body and the masses, more or less filling each part of the body with lines of deconstructed color.

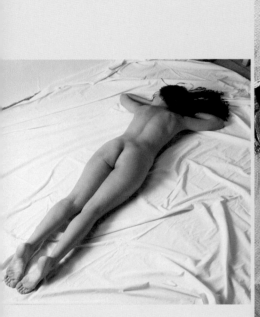

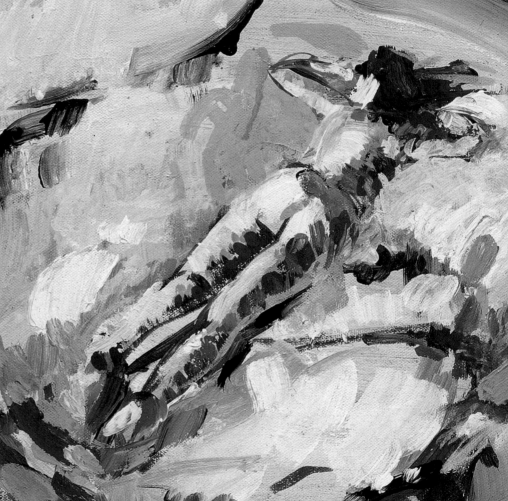

09 Modeling
Creative approach

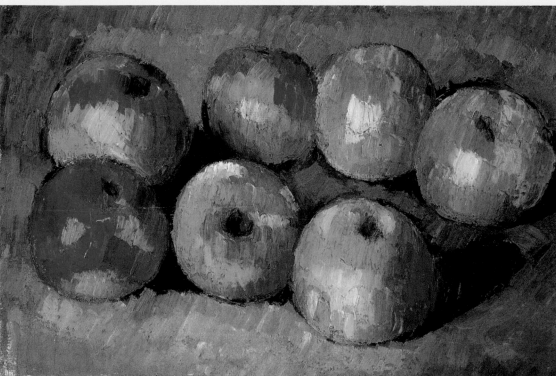

Paul Cézanne
Apples, 1877–1878
Fitzwilliam
Museum
of Cambridge
(United Kingdom)

To properly understand the modeling technique with oils we must talk about a fundamental reference in the history of painting, Paul Cézanne (1839–1906). This artist, precursor of Cubism, lived in southern France, away from the Impressionist influence of Paris. Cézanne painted in his country refuge of Aix-en-Provence, outdoors, right in front of the "motif." He approached the forms from their internal structures and was not at all interested in the illusion that the changing light created on them. Cezanne pursued what he called "a constructed harmony," which would reconcile the tensions "through a correct placement of the color contrasts," believing that "nature cannot be found on the surface but in the depths." To paint any subject, he focused on strict laws, modeling the color according to the light of each volume, not letting himself get carried away by the visualization of the light reflecting on the surface. We appreciate all this in his work *Apples,* where he confidently revealed the fruits' internal structure, the sphere, with a few decisively modeled strokes.

Modeling apples using their basic structure

In an attempt to work from an analytical point of view, Gemma Guasch, like Cézanne, discovers the internal structures that govern each form. Oil sticks make it possible to work the forms using mass—diluting them in essence of turpentine—or a linear structure, leaving the strokes as they are. The firmness and malleability of the sticks have given the artist the discipline and concentration needed to model and structure the still life appropriately.

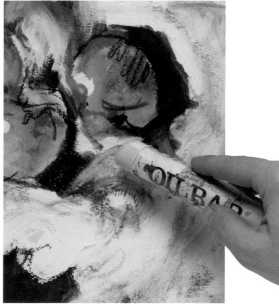

" *Every tone is interpreted, every form is intertwined. This is coherence.*"

Paul Cézanne

Step-by-step creation

1. On a linen canvas primed with gesso, the basic forms that define the volume of each apple and its spatial relation to the fabric are structured. Oil sticks are used directly and then wiped with a thin bristle brush wetted with essence of turpentine. This dilutes the oils, achieving a light and transparent stroke.

2. The focus moves to the construction of each apple, modeling them with different tones: reds, yellows, and greens. The internal structure of each apple is defined properly and directly with the sticks. Next, a few areas are blended with the finger to emphasize their round shape. Finally, the canvas is completed as if it were a relief, by painting the shadows.

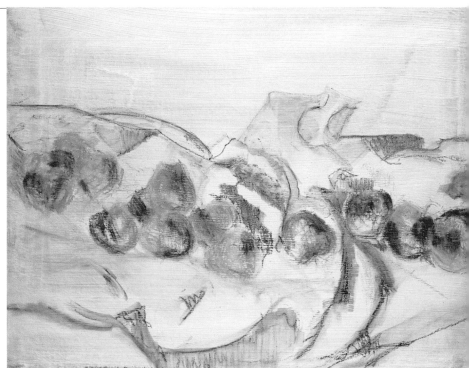

3. Painting proceeds by modeling the apples, each time more decisively and firmly. A black oil stick is used to model the darkest areas of each apple and of the material in general. Direct application of the oil sticks is alternated with blending with the finger in some of the areas, in an attempt to define their internal structures.

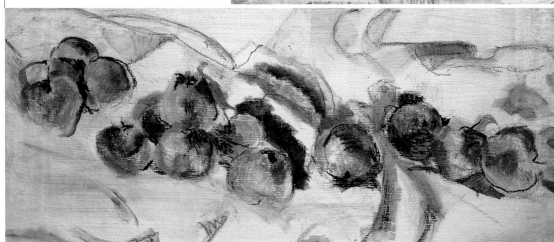

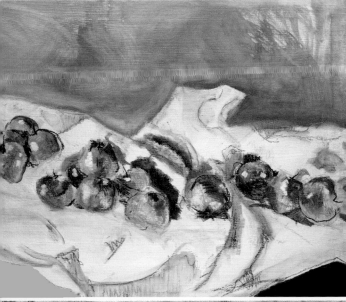

4. To emphasize the relevance of the apples, a decision is made to darken the background. Black oil stick is applied to the lower part very heavily. On the upper part we dilute the blue oil stick with essence of turpentine, creating a more airy and appealing effect.

5. The work is finished by applying the black oil stick directly over the blue background. The application of firm strokes horizontally and vertically on the blue mass restores the vitality of the scene, letting the apples gain relevance, modeled over a white cloth that is left almost untouched.

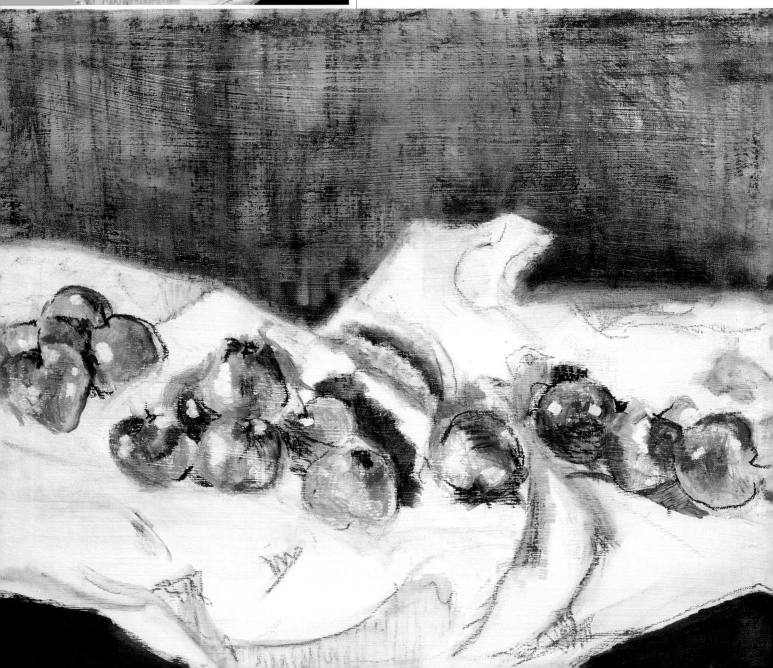

09 Gallery

Other versions

To create the basic shapes that define the nature of each form and its spatial relationship with the surrounding space, these examples work very differently with the oil sticks. Diluting the sticks, blending them, applying them thick or mixing them with oil paints creates a very rich and varied gallery.

These apples have been modeled with decisive strokes, letting the blacks and whites contrast sharply with the round forms. Black blended with a brush diluted in essence of turpentine was applied to the background. A few shaded points in black are applied to the cloth as contrast, but the white has been left untouched as much as possible. With all this, the artist achieved a strong and firm modeling, which has great expressive power.

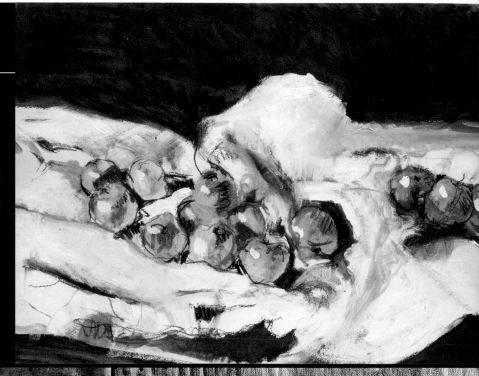

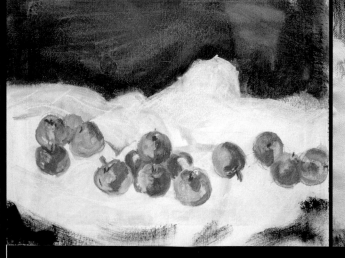

The application of essence of turpentine over the areas painted with oil sticks produces a subtle and transparent modeling effect. The absence of black in the structuring of the volumes magnifies the color of each apple. For the background, black paint is applied with a medium wide brush, leaving the brush marks visible.

In this painting the oil sticks are applied directly and without any manipulation. The artist models the forms with hatching, leaving the raw brush marks and achieving a result that is very close to the sketch.

This work achieves a softer and cleaner approach, where the white dominates the space of the background, making it immaterial and delicate. The volumes have been modeled by blending the different tones with the fingers, and the resulting apples are softer and rounder.

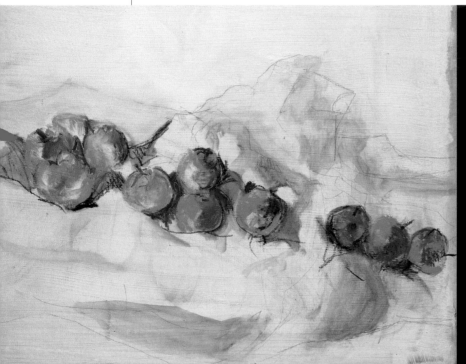

A closer modeling defines this work done exclusively with a brush and oil paints. The canvas is worked as if it were a relief, defining each plane completely, structuring them, and changing the direction and the modeling of every part. The apples are relegated within the canvas to a second level; they are integrated as if they were the elements of a landscape.

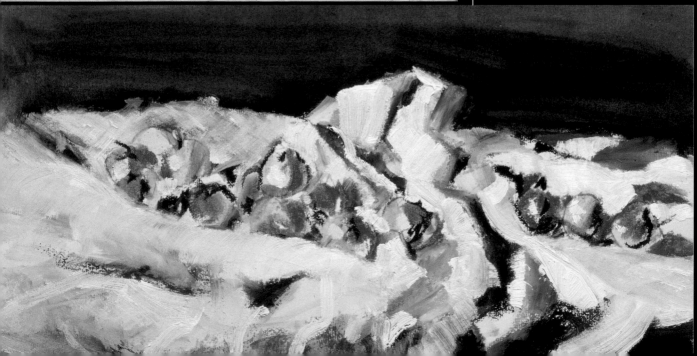

09 Window

New approaches

Another view To plan another approach, a decision is made to avoid modeling with different strokes, saving the energy and the movement of the brush. In the first painting, this achieves an atmospheric work, where each apple is defined only with slight horizontal lines. The color has also been modified, using a neutral monochrome over a greenish background. In the second, vertical strokes are used, partially blurring out the oil sticks with an eraser. Here, the pastel tones favor the volatile and immaterial aspect of the forms.

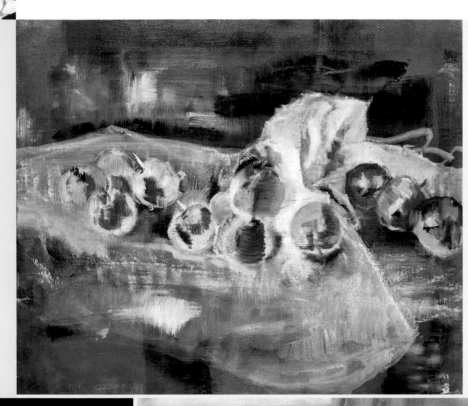

Another model In keeping with the basic analysis of the forms, Gemma Guasch has focused on the modeling of a lemon over a red and black background. A simple and minimalist composition mimics the austerity of the mystical still life of the Spanish Baroque period, where forms were modeled with maximum respect and attention. The oval shape that defines the lemon has been painted without the spiritual connotations, but with the intent of creating the internal structures of each object.

10 Monotypes
Creative approach

Josep Guinovart
Monotip com a petjada, 2006
Private collection

Josep Guinovart (born in 1927) is a multifaceted artist who has always been characterized by his great creative freedom and the desire to explore materials and techniques. During the 1950s he founded the group Tahull together with Cuixart, Tàpies, Muxart, and Tharrats, and he established himself as the artist with the radical views in the use of collage and assemblage. Guinovart has created a symbolic universe charged with poetry. With the presence in his work of branches, sand, stones, wheat, as well as objects of daily use such as plates, rope, and farming tools, he establishes a connection with nature in depth and strength. The colors of his palette have a tight relationship with his roots and his surroundings near the Mediterranean sea: the ultramarine blue, the iron oxides (ochre and red), the white, and black, and of course, the natural colors of the materials that he incorporates. As far as form is concerned, the presence of ovals and circles is constant, as symbols of seeds or elements of the cosmos. Guinovart works in a spontaneous manner, creating through feeling, without preliminary sketches or very precise images, facing the abyss with total freedom. A characteristic that defines him as a printmaker is that the graphic work is always lightened by hand, thus making it unique. It is even more unique when it is a monotype, like *Monotip com a petjada*, a splendid piece that the artist made expressly for this book.

Painting on a plate to print a unique work on paper

The monotype is a technique that consists of making an image on a plate or some other material and then printing that image on paper by applying pressure. This method creates very different effects than normal painting and, at the same time, unique and unrepeatable prints, because they are not a permanent image on the plate. In this creative project Josep Asunción has created a series of monotypes with an abstract theme, inspired by an antique chest in his studio.

> "The proximity of space causes me to be carried away by the euphoria and illusion of the moment, that is how I let loose."

Josep Guinovart

Creative techniques **oil**

Step-by-step creation

1. The first lines on the plate are made with a foam roller soaked with oil color that is a little diluted with equal parts of linseed oil and essence of turpentine. To create a very uniform texture it is essential to make several passes without pressing too much on the applicator. Applying pressure will create some texture.

2. Next, some light areas are created by lifting color with a dry sponge. The gradation can be varied by the pressure and movement applied. To make lighter areas the sponge is dampened with diluent; in this case the plate should be printed after the solvent on it has evaporated.

3. An impression is made with a press by centering the paper and placing it on the plate with the image side up, exerting as much pressure as possible, with the plate and paper between two boards. The printing takes place immediately; there is no need to wait to remove the work from the press. It helps to dampen the paper a little and to put some kind of soft fabric (felt, a blanket, rubber, sponge pads) between the upper board and the paper so that it will adapt to the press plate and not slip. The print can also be made by hand with a bottle or the back of a spoon by pressing while making circular movements on the paper; an etching press may also be used. In any case, the plate is below with the paper on top.

4. After the first printing, the image is too light; it lacks paint and brightness, so another coat is added with the roller. Erasing is repeated and it is printed again. This time, a reserve made with a cardboard stencil is created and some oil paint is added directly from the tube.

5. This second printing is more intense. The marks of the color from the tube have flattened and spread; the reserve has protected the base on the paper with the traces of the light image of the first printing.

6. Adding a third step, a direct drawing on the back of the paper, completes the monotype. First we spread some color on a sheet of glass or on the plate if it has been cleaned.

7. The paper is placed carefully on the plate, taking care to barely touch the colored area to avoid accidentally transferring any of it. Drawing is done on the back of the paper with a pencil, applying pressure without touching the area with the hand and avoiding moving the paper until the drawing is finished.

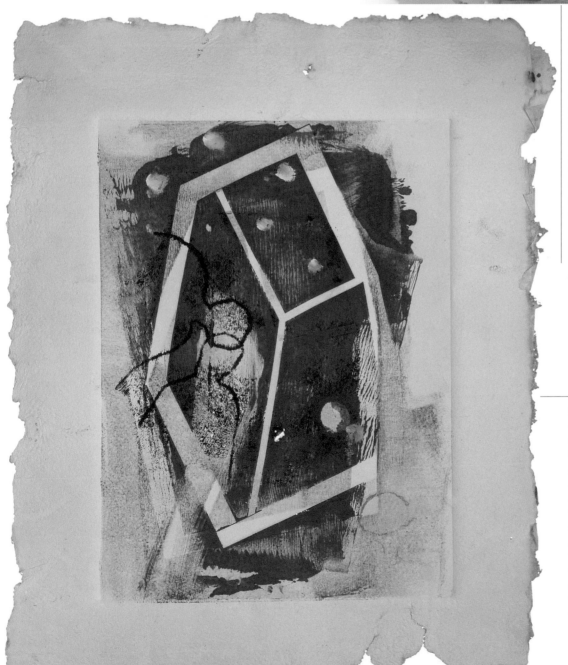

8. The finalized monotype is a combination of techniques: rolled color, lifting, stencils on the plate, and drawing directly on the paper. The completed image is an abstract interpretation of the theme of the chest as a container, a space that hides a mystery to uncover.

Creative techniques **oil**

10 Gallery

Other versions

By combining all the monotype techniques, the artist has made a series of very different prints with a common denominator: the theme. The presence of a square figure more or less synthesizes the idea of a container, and the more organic forms, often human, suggest the relationship between man and that mystery to be revealed.

This monotype was printed twice. On both occasions the drawing was made on the plate, which was first rolled with paint. Lines were made in the fresh paint with a barely sharpened pencil to create a white drawing. The lower figure was defined in the first printing; however the container was printed twice.

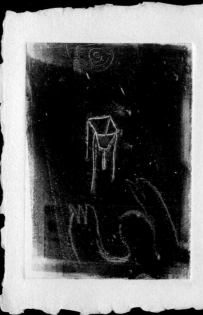

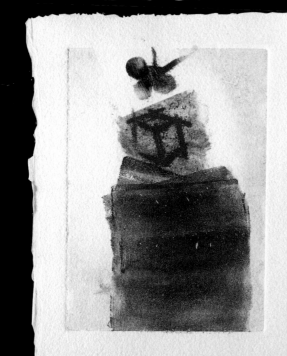

The first printing of this plate created the red background with the white reserve. The green and yellow marks appeared in the second; the green was applied to the plate with a brush, creating a light blending toward the edges, and the yellow with a spatula to leave some texture. In the last step the red lines were defined by a direct drawing on the back of the paper.

This work was printed just once, but it also has direct drawing. The areas of color, and the trefoil made with a cardboard stencil that allowed the blue background to show through, were printed. The cube was made later by a direct drawing on the back of the paper.

This monotype has the most texture, because it has made full use of the texture of the roller and the hatching created where the color overlaps. This one consists of three steps: first was the creation of a black background with stencil reserves; the second consisted of printing general areas of reddish color made with a textured foam roller and paint diluted with essence of turpentine; finally, drawing was done directly on an area of very creamy white paint to create lines.

This work is the result of two printings. The first consists of very pale greens and pinks for the background. The second is a clear image lightly printed by laying a stiff cardboard cutout over a plate covered with brown paint. The linear marks of people and letters were made with a corner of a piece of cardboard; the lines of the cube were made with the side of the cardboard. If work is done on a metal plate a spatula can be used, but on acrylic it is better to use cardboard to avoid scratches.

This work began by using the paint left on a plate after printing another monotype, which later became the red and green monotype in this gallery. A brown mark was made in the center with a rag, a small piece of cardboard was used as a reserve, and diagonal lines were drawn from the corners. After this was printed, a second impression was made with ochre and green paint applied directly over the white of the reserve, and the work was finished with a direct drawing in black over the previous colors.

Another version All of the monotypes for this project have chromatic vibrations produced by color contrast or subtle glazes. But to experiment with a more radical version, Josep Asunción has worked without the color and the organic forms that always accompanied the geometric container. In this monotype the image is reduced to two basic structures printed in a single pass. The white color was created by scraping the plate inked with smoky black oil paint and with a reserve made with a cardboard cutout.

Another model Getting away from the theme of an object, Josep Asunción decided to illustrate the flowing water of Muga Caula, a well-known waterfall in a village of Girona province in Spain, where Marcel Duchamp and Man Ray enjoyed restful vacations. To interpret the constant movement of the water in an abstract form, the artist printed the monotype with an etching press, causing the paint to spread and drag, since the press uses rollers instead of vertical pressure. The edges of the color were made to run by adding extra essence of turpentine to the mix, and the blending effect resulted by applying dabs of different colors at the top of the plate, next to each other but not mixed.

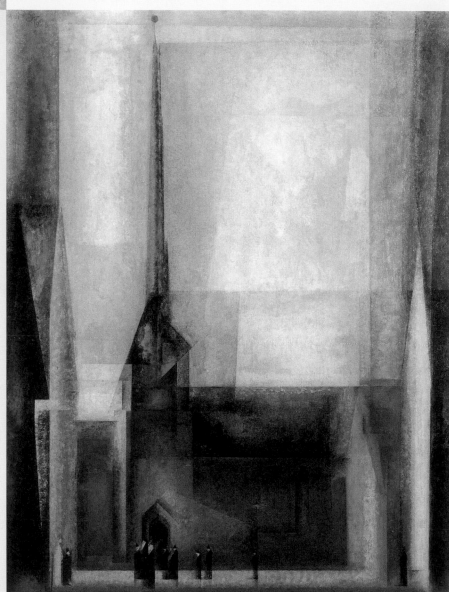

Lyonnel Feininger
Gelmeroda IX, 1926
Museum Folkwang
(Essen, Germany)

Lyonnel Feininger (1871–1956) was born in New York to a German family that was completely devoted to music. In 1887 he went to Germany, where he decided to abandon music to work full time as a painter. He received his artistic training in Germany and Paris, where he became attracted to the purity of form of Cubism and the subtle imagination of Seurat. During this period he met Franz Marc, who invited him to become part of *Der Blaue Reiter*, and Walter Gropius, with whom he shared his pictorial views. His friendship with Gropius encouraged him to become a professor at the Bauhaus school, where he conveyed his vision of being a free painter and subsequently became a model to follow. Lyonnel Feininger focused on spatial and rigorous design in his paintings, without pictorial intoxications. During his bicycle rides through the landscape of central Germany and his stays near the Baltic Sea, he discovered silence. His creations, with crystalline forms and refined tones, are structured within rigorously balanced compositions. *Gelmeroda* forms part of a body of thirteen canvases that aspire to be a metaphor of a desire of the infinite expressed with the finite of his crystalline forms, created with the application of glacis. Their immaterial feeling is reminiscent of a fugue by Bach, just like the ones the painter played in New York as a child.

Applying glacis to create transparency in a still life

To experiment with the poetic and crystalline possibilities offered by the glacis technique, Gemma Guasch has developed a creative piece with a still life. Glacis consists of applying layers on a dry suface. Each new layer of paint is applied over a dry one, with dry bristle brushes charged with a small amount of paint and without covering the previous layer completely, letting the color come through. Since oil paint is a slow drying medium, its application requires more time and control. Spreading it with semi-covering dry layers of paint favors this crystalline and transparent effect, providing the magic appeal of glacis.

"From childhood, the church, the mill, the bridge, the house—and the cemetery—have awakened deep and reverential feelings in me. They are all symbolic..."

Lyonnel Feininger

Step-by-step creation

1. With a piece of charcoal the overall structure of the still life is lightly defined. Then, with a flat bristle brush, without any solvent, the contours defining only the darker areas are drawn. To do this, the artist has used two tones that keep the painting from losing the white candor provided by the porcelain pieces: a light gray and a soft pink.

2. With the same dry brush charged with a small amount of paint, the artist defines the space that surrounds the objects in large areas of light grays, alternating violet grays and pink grays. Dark gray is applied only on the shadows projected by the objects. Avoid heavy paint by completely spreading it on the support, which will speed up the drying process so that other layers may be applied.

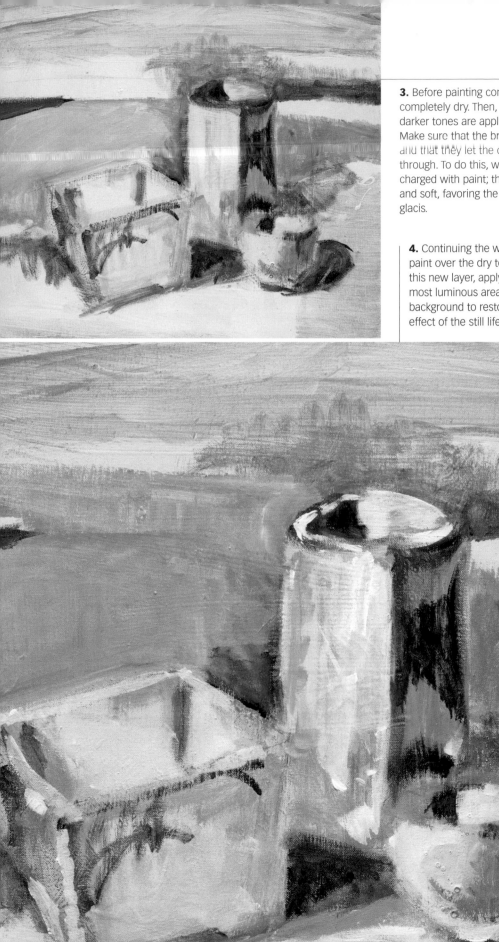

3. Before painting continues the previous layer must be completely dry. Then, with a round short bristle brush, the darker tones are applied in the darker areas of the still life. Make sure that the brushstrokes are not too close together and that they let the colors of the previous layers come through. To do this, work with a dry brush that is not too charged with paint; this way the brush marks are intermittent and soft, favoring the characteristic transparency effect of glacis.

4. Continuing the work with layers of glacis, paint over the dry tones with dry brushes. On this new layer, apply warm rose tones on the most luminous areas of the objects and the background to restore the warm and appealing effect of the still life.

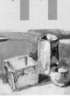

11 Gallery

Other versions

Glacis creates a subtle and magical background of chromatic shades. To appreciate the various transparent effects, this gallery presents these characteristics on different supports: handmade paper, textured paper, linen canvas, cotton canvas, acrylic, and wood.

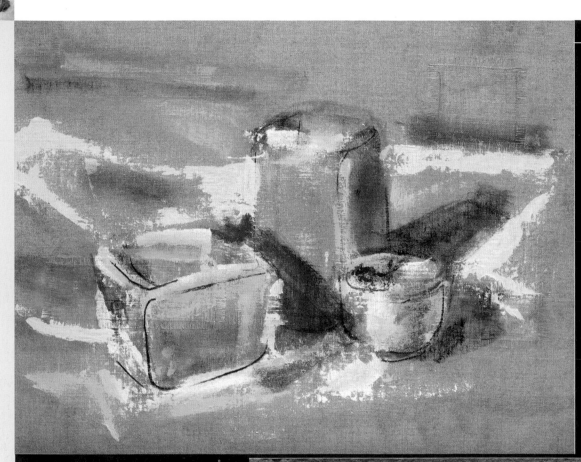

In this piece the glacis effect is applied over a piece of unprimed linen canvas. The artist has chosen to work directly with a dry brush, defining only a few areas of the objects. Finally, the contours have been drawn with chalk to define the objects more and to favor the texture and tone of the linen.

A red handmade paper provides a darker background tone. The objects have been worked over it with a clean and luminous white, shaded with subtle rose gray and yellow tones. Handmade paper requires more paint to·cover the whites and favors the contrast with the red tone of the paper.

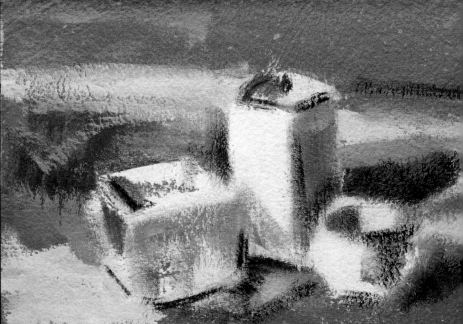

This watercolor paper offers the ideal textured base to work the various gray tones; here, the warm and cold grays are mixed together to define the space and the areas of shadows. In the luminous areas the artist has decided to let the support itself come through, contrasting it with the application of glacis for the gray tones.

Acrylic provides a transparent effect. That is why the application of glacis has been painted on the underside of the acrylic with white paint. Then, the top has been painted with dark gray tones defining the dark areas of the shadows. To finish, yellow and rose tones have been incorporated to add warmth to the pieces. The final work offers a different view of the glacis because the layers can be physically seen within the support.

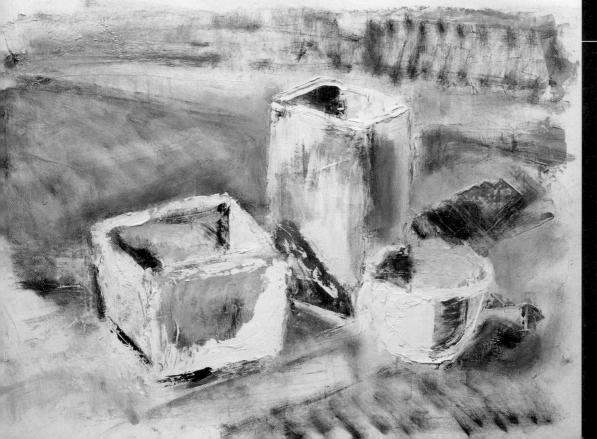

This porous cotton fabric is the ideal support to create a textured piece. The artist has applied the different gray tones first and then the white brushstrokes have been worked in, which the different grays of the first layer subtly show through. To conclude, the whites of the most luminous areas have been painted over to emphasize the contrast.

Creative techniques **oil**

11 Window

New approaches

Another view All of the previous pieces were done on different supports. Each support favors the application of glacis, but the still life theme, whose volumes have been defined with a subtle chiaroscuro, have not been altered. To change the focus, the artist has decided to explore the immaterial nature of glacis by modifying the logical order of chiaroscuro and the definition of the areas of color. One of the pieces has been done on a canvas board with a very wide bristle brush charged with only a small amount of paint, which lets through an undefined form that creates a vague image, like floating particles of light and shadow. The other piece has been painted on a wooden board, with a medium flat synthetic bristle brush. Since this brush is very soft and the support has a slight grain, the result is very soft and appealing.

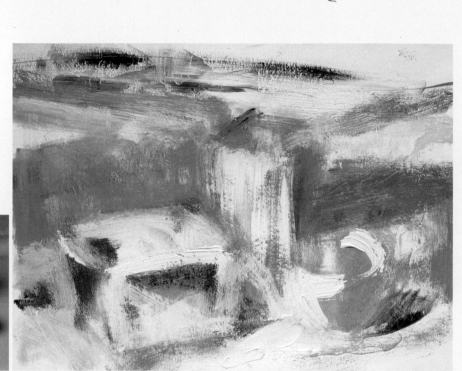

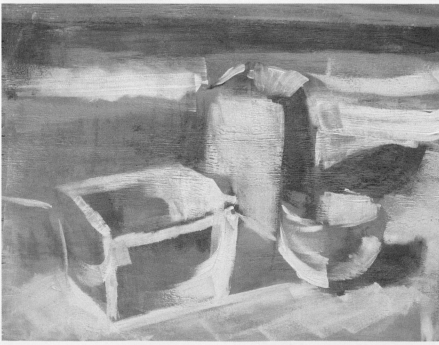

Another model To vary the effect achieved with the glacis on a still life of white porcelain, this time the artist has decided to use a more complicated and tenebrist image. This model offers a view charged with drama and contrast. The transparency effects achieved in this work offer intense and contrasted results. The austerity of the garlic arranged at the end of a table is reminiscent of Baroque still lifes. The glacis technique has been used on textured paper with a bristle brush. The application of the different tones has been built up with layers, making sure each time that the previous color was dry.

12 Tenebrism

Creative approach

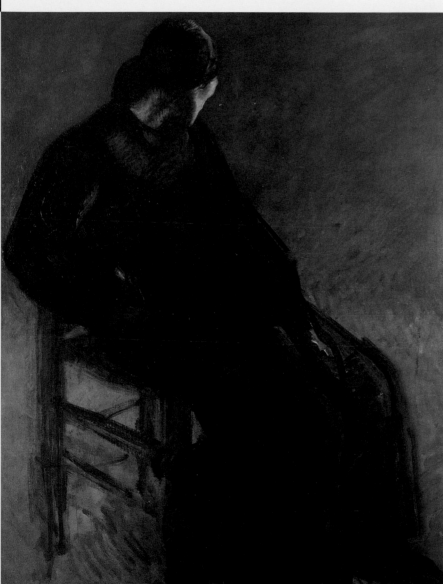

In a style that was modern for his time, Isidre Nonell (1872–1911) developed a personal painting approach that soon stood apart from Catalan Modernism for its austere and tenebrist esthetic. He was always interested in themes that opposed the bourgeoisie society of the time: the marginal, lonely, sickly, and poor people, especially gypsy women, in whom he found a great source of inspiration. His school could be found in the slums of the city's outskirts and the bars in the poor neighborhoods of Barcelona. The radical approach caused him acceptance problems and difficulty in selling his work. This is why he focused even more on his extreme style. On the one hand the subject matter fulfilled his true interest, the plasticity of art; and on the other, it exhibited his devotion to the real world, without disguises, but also without exaggerations. He painted with thick and oily paint. His paintings have density, as if he had been painting them for a long time. The color seems to emerge slowly. In many paintings, such as *La Viuda* (*The Widower*), he conceals the figures by making them bend forward, sometimes even showing them from behind to convey the importance of the paint, the simplicity of the forms, the sensuality of the colors and of the brushstroke, but not of the model. When he was asked the reason for this approach he would say, "I just paint and that's it."

Isidre Nonell
La Viuda, 1904
Private collection

Using tenebrism to add intimacy in a maternity scene

Tenebrism helps focus the eye on the theme in mysterious contemplation, showing the figure without distractions, without a background, and in a pure state. In this project, Josep Asunción wanted to apply this technique to a universal theme: a mother with her child. Thanks to the theatrical lighting effect, the figures look like an apparition amid the dark surroundings. The work was done on canvas, modeling the figures with soft brushes, and with the help of a rag to create the atmosphere.

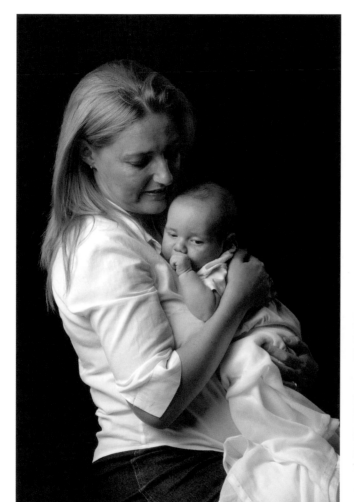

> "*Nonell has made us and here we are living our mysterious existence and showing our dark ugliness as if it were an open sore before the people who enjoy their Sunday routines, who wear their best clothes...*"

Rafael Nogueras Oller. Fragment of an imaginary dialogue between the gypsies of Nonell exhibited in Barcelona. *La Tribuna* newspaper, November 23, 1903.

1. The artist begins with an old painting to take advantage of the texture. First, a layer of indigo blue paint diluted with a little bit of walnut oil is applied to make some of the lighted areas of the previous painting show through. When this base is dry, work begins *alla prima*, without a preliminary drawing, establishing the areas of light with a thin round sable brush and Naples yellow paint. This approach is risky because mistakes can be made in the portrait resemblance; therefore, it is a good idea to work slowly and carefully.

2. Application of more color in the lighted areas of the figures continues. A wider brush, also made of sable hair, is used to create soft and light areas of color. The paint is diluted in oil; this makes it possible to apply thin and even brushstrokes, without more texture than that of the previous painting.

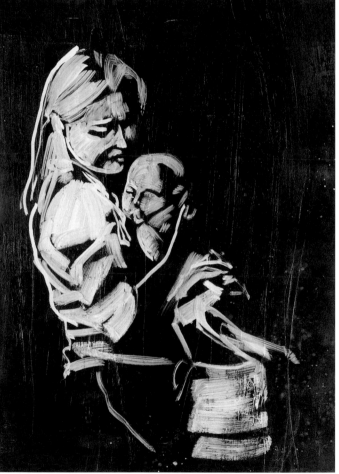

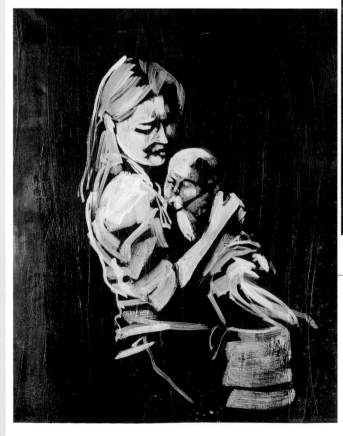

3. The scene is completed by painting the areas of light on the mother's arm and the child's face. It is important for the lines to follow the direction of the real model. The brush should follow the natural flow of each volume, as if caressing the forms, without repeating or blending the colors. Even though working this way is riskier, it makes it possible to preserve the freshness and the austerity of the painting.

4. Next, the atmosphere is created by lifting off paint. Gently wipe the entire surface with a clean cotton rag, always moving it in the same direction. After each stroke of the hand a little bit of the portrait is removed; therefore it is important not to wipe too hard or the work will be erased completely and the image will become blurry.

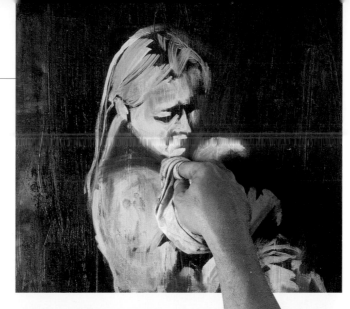

5. The image is quite blurry, but it is not completely erased. The artist has gone over the mother's arm with the rag several times, applying pressure, to expose the blue of the background. The faces have been approached very carefully so the features would not be lost. If the images were erased too much with the lifting procedure, wet the rag with solvent and start over. This is better than repairing the images with localized brushstrokes and blending with the brush.

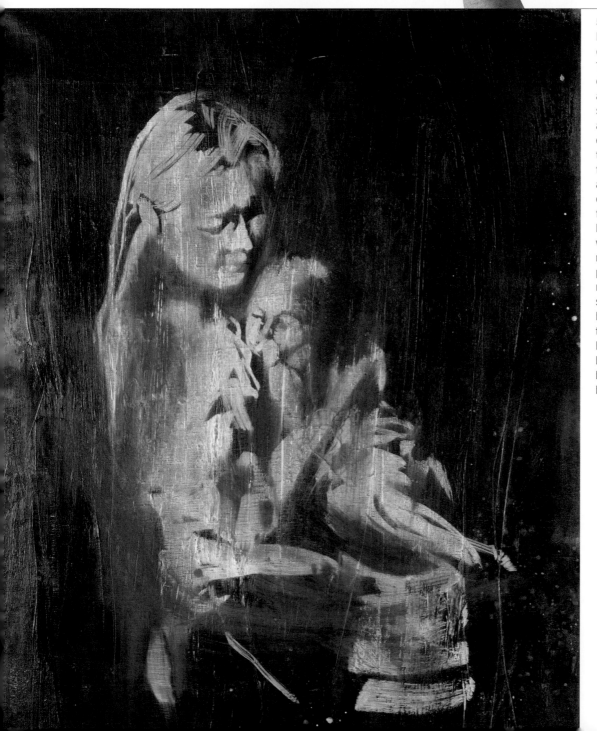

Creative techniques **oil**

12 Gallery
Other versions

Using the same color scheme but changing the layout, Josep Asunción has made several interpretations of the same mother with child scene. Depending on the density of the paint or the closeness of the image, the result can either be more intimate or colder.

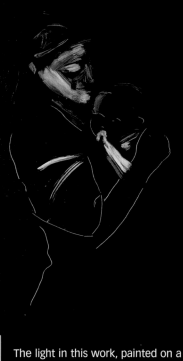

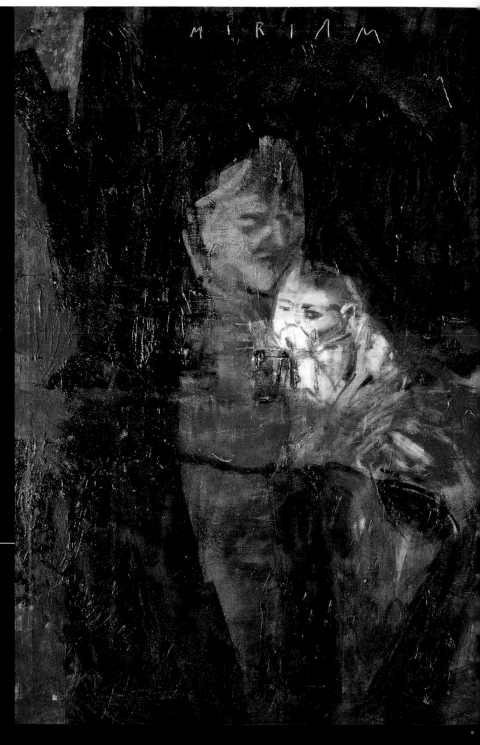

The light in this work, painted on a sheet of brass, has been created by removing the layer of blue oil paint. The thin lines of the contours have been applied with a spatula and the soft colors of the arm and the face of the child with a dry sponge. The simple and delicate finish gives the painting a poetic feeling, even though it lacks atmosphere and warmth.

This large format painting has also been painted on an old recycled canvas to take advantage of its texture. To convey the feeling of tenebrism, the areas of light have been painted and then wiped off with a rag to create the atmosphere, but the areas of light on the child have then been repainted with a white color, to highlight its figure separately from the rest. This effect adds drama to the theme, and emotional intensity.

A close view of the child shows this theme in a different light, because the mother disappears as subject matter and becomes the support for the true theme: the child. It looks as if the mother is inviting us to hold the child in our arms or to take a closer look at him. The painting has been worked with a soft brush and a rag on a recycled canvas.

This piece has been painted on a large piece of Chinese paper. To create washes, splatters, and dripping over the background we have worked this area with oil paint diluted with essence of turpentine. We approached the figures more carefully, applying the technique on a dry surface with a sable brush slightly charged with paint. Only in the areas of clothing and the hair, have we diluted the color a little bit.

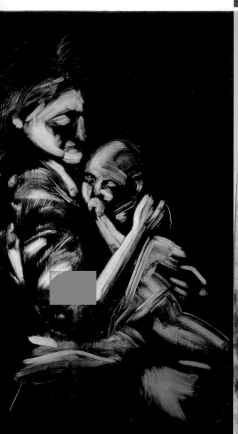

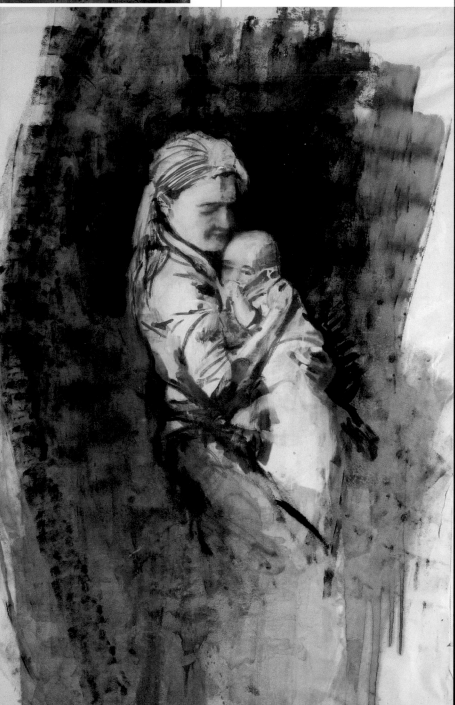

This mother with child image has been painted on a sheet of brass mounted on a frame. It is the most striking piece in the gallery because the light in the tenebrist style painting is constituted by reflections on the metal itself. The modeling was done by removing the fresh color with rags, directing each stroke and controlling its pressure. A layer of retouching varnish was previously applied between the metal and the oil paint.

Another view Is it possible to create a tenebrist feeling without very much light contrast? This question has inspired Josep Asunción to try a very limited chiaroscuro color scheme. He has primed a wood board with a red acrylic base and over this background he has painted the areas of light on the figures with white and yellow paint. To create the atmosphere he has wiped the entire painting with a rag. The final result is very warm and intimate, with little drama. The protagonist of the painting is the light.

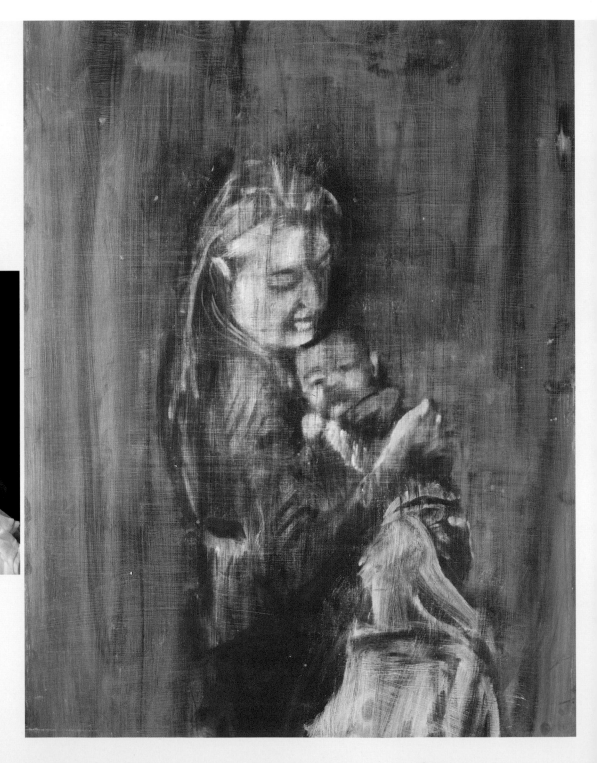

Another model For a change of model and to experiment with other tenebrist forms, the artist found a life model from nature that instills tenderness and emotion: a group of deer. This time, he was forced to alter the light by eliminating the background with a pasty and dark atmosphere using Van Dyck brown paint. White and raw sienna are the colors used to create the light areas of the figures. Also, here the painting has been done on recycled canvas, which provides the relief and textures that convey drama and density to the scene.

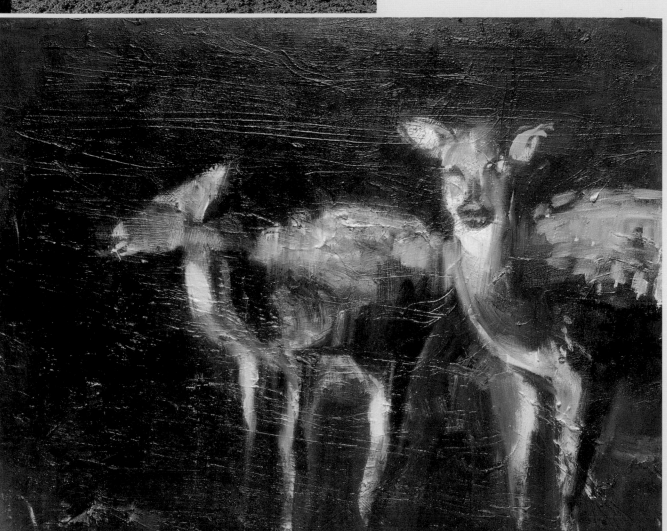

13 Manipulation
Creative approach

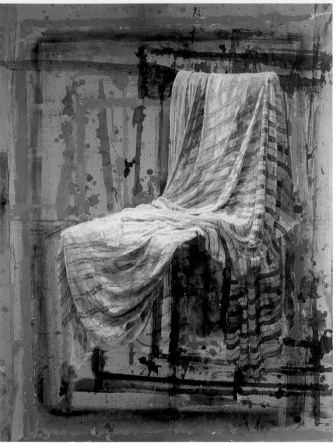

Safet Zec
Lenzuolo sulla sedia, 1998–2001
Private collection

The work by Safet Zec (born in 1943) is a strange combination of correctness and experimentation. He was trained as a printmaker and a painter in the Fine Arts Academy in Belgrade. In 1992, he fled the war in former Yugoslavia and took up residence in Italy. Since the 1990s he has been considered the most important artist in Bosnia-Herzegovina, his native country. Contemporary critics consider him the most important exponent of a new current called Poetic Realism. The social, political, and military experiences that he lived in the mythical city of Sarajevo are reflected in his entire body of work, which is shrouded in mystery. His still lifes live in a worrisome silence; in them he questions his history and his memories. His love for recycled and manipulated material is evident in *Lenzuolo sulla sedia.* In this painting he shows pieces of cloth hanging from a non-existing chair that are technically perfect, created with lines, drippings, and accidental stains on the support.

Manipulating materials to paint an old, worn stairway

An old staircase in a state of disrepair is an ideal subject for experimenting with the manipulation of materials. The theme lends itself to the representation of cracked and uneven walls and worn-out steps. Gemma Guasch has seen in this model the possibility of mimicking Zec by painting on a recycled support. She begins with a piece of cardboard from her studio with spatterings from other paintings. The artist will use hard brushes, sandpaper, and wide scrapers as applicators. All the materials chosen lend themselves to experimentation.

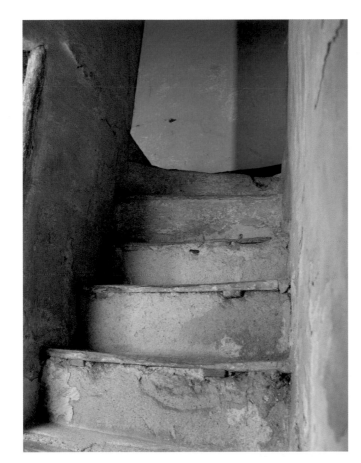

"I have no fears about making changes, destroying the image, etc., because the painting has a life of its own."

Jackson Pollock

Step-by-step creation

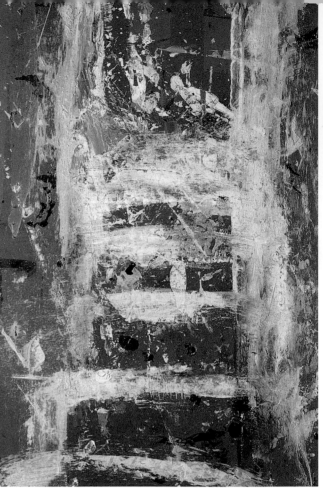

1. An old piece of pressed cardboard that has the traces of many days of work in the studio—and the marks of other supports that were placed on it—is chosen. The spattering and drips have not been planned or studied beforehand.

2. The structure of the staircase is laid out with white paint applied with a hard bristle brush. Titanium white is chosen to make it lighter and to preserve the freshness of the spattering on the cardboard.

3. The staircase is worked with a chiaroscuro approach, emphasizing its tones and values. First, a flat brush is used to paint the darker areas of its shadows with burnt umber. Then, with a wide brush the stairwell is painted with a light green. Working dry on dry speeds up the drying process and makes the work easier. Finally, with a wide scraper the background is partially covered using two different blues: sky and cobalt.

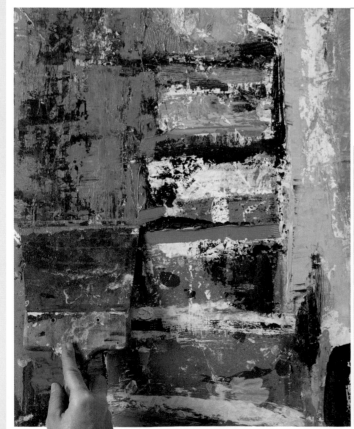

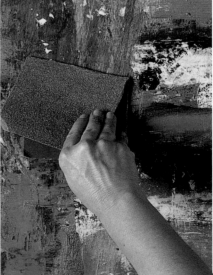

4. To make scratches and lines in the paint, the wet paint surface is brushed with a hard brush. It is allowed to dry completely and then, a piece of sandpaper is used to lighten and reduce the layer of paint, making it sparse. This obtains uneven surfaces that express character and hardness.

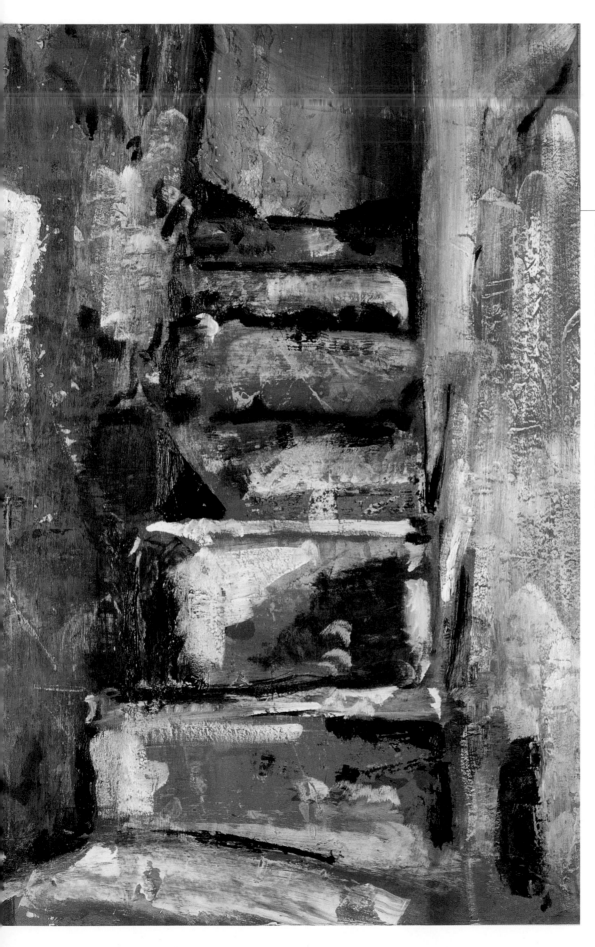

5. The areas of light are painted with titanium white using a dry flat bristle brush. The dry brushstroke does not have great covering power and creates texture. Then, with a round synthetic brush, details are added to the dark areas with a natural earth tone. These applications define the shape of the staircase while respecting the recycled background.

Following an experimental and creative approach, Gemma Guasch has worked with unconventional applicators and products. The willingness to paint with techniques that are considered alternative—sgraffito and washes—has produced very attractive results.

Manipulation

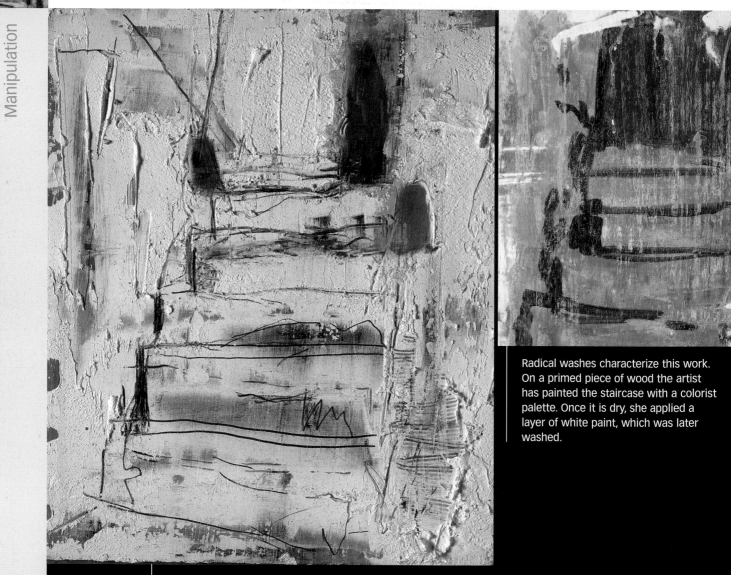

Radical washes characterize this work. On a primed piece of wood the artist has painted the staircase with a colorist palette. Once it is dry, she applied a layer of white paint, which was later washed.

On a piece of primed board, the artist has painted the staircase with bright and saturated colors. Then, with a wide rasp and white paint, she has covered the support completely. To finish, the thin lines were made with sgraffito, using a pencil, and the wide lines were made with a spatula. The sgraffito makes it possible to see only partially the work that is hidden underneath, which creates the urge for the revelation of the rest.

Creative techniques **oil**

The different qualities of texture can be appreciated in this painting. On a very old piece of pressed cardboard the artist painted the staircase with a spatula and dark colors. To produce an appealing and atmospheric effect, she has blended some areas with the fingers and a rag. Finally, a few glazed areas of various consistencies give the staircase an atmospheric and mysterious feeling.

A recycled canvas with a bright orange background is the base this time for a painting with rich dark shades. To produce this effect, the painting has been covered with Holland varnish; when it was still tacky the artist sprinkled powdered asphaltum over it. To finish, a few small lines have been scratched with a spatula to expose the strong color of the base.

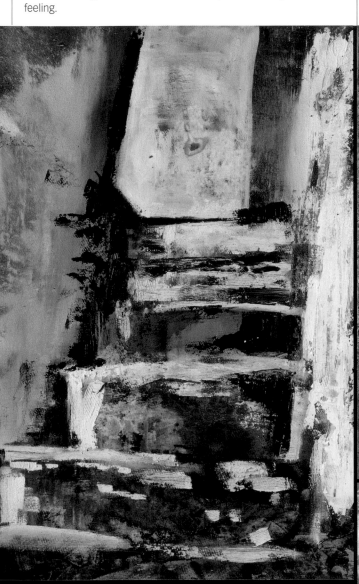

In this work we find an atmospheric and tenebrous effect. On a wood board primed with gesso tiinted with English red paint, the artist has applied a thin and dark glaze. Over it, with a thin brush and raw umber, the dark areas have been emphasized with light blending.

13 Window

New approaches

Another view In all the works, manipulation has been approached through the use of painting techniques. With the idea of finding a different focus, Gemma Guasch has resorted to collage, using simple and recycled materials, like pieces of newspaper, masking tape, and scraps of painted paper that she found in her studio. She tore these papers with her hands to maximize the spontaneous character of the piece and she glued them to the support with latex. The work is finished with a few lines painted with asphaltum. The collage, created inexpensively and with simple materials, is a reminder that creativity stems from our capacity for seeing things in a different way.

Another model Before, the central theme of the project was an interior, but this time the artist has chosen a very different model: a nude. The quality of the well-lighted skin and the use of recycled cardboard provide the perfect subject matter and material for manipulating and for finding new expressive possibilities. The torso was painted with small impastos, the paint applied with the finger and with the spatula. Then a white glaze was applied to much of the painting, leaving the torso and part of the cardboard exposed. The final piece is powerful and dramatic.

13

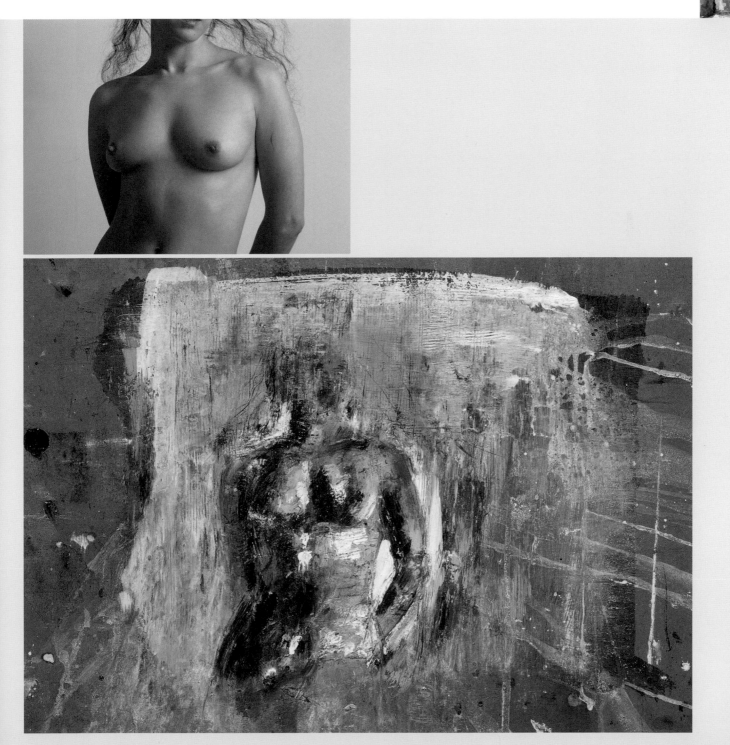

14 Mixed media
Creative approach

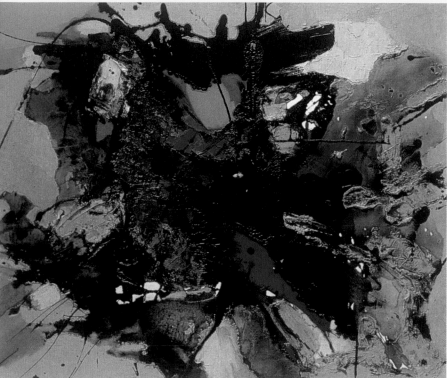

Tadeusz Kantor
Painting, 1959
Museum Narodowe
(Warsaw, Poland)

Throughout the twentieth century, many artists experimented with combinations of oil paints and other media. By mixing oils with enamels, India ink, charcoal, acrylic, and varnishes they achieved different and innovative results. We can place the Polish artist Tadeusz Kantor (1915–1990) among these spirited artists. He was a painter, sculptor, and staged "happenings," installations, wrappings, and stage designs. He was also an author, theater director, and the creator of the "theater of death." Inspired by Russian and German Constructivism, Dadaism, and Surrealism, and fascinated by ready-made and discarded objects, he developed his entire creative output, both his paintings and his theater, with an abstract and gestural emphasis. Kantor was a multifaceted artist who is difficult to classify; his need for movement and action were manifested in his life and his work. The gestural approach, the experimentation, and the dynamism reflect the image of an innovative personality, which is evident in his paintings.

Abstraction as the ideal space for mixing mediums

With an innovative and daring spirit that does not limit itself to the use of each medium separately, Gemma Guasch has conceived a piece that is more experimental and unorthodox. Mixing media—oils, India ink, varnishes, enamels—has resulted in something innovative and surprising. The model is only a source of visual stimulus: an empty space bathed by the sunlight that comes in through the windows. Without the restrictions for the application of the colors and the lines, each medium has been applied on the canvas liberally, abstraction being the most accurate focus for this piece.

"My work has been my house, the painting, the show, the theater, the scene."

Tadeusz Kantor
Notes from the program "Today is my Birthday."
Krakow, 1991.

Step-by-step creation

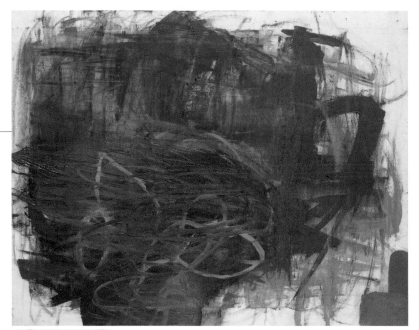

1. A previously used oil painting is recycled. This takes advantage of the texture and the colors as the background, from which the artist can begin to experiment.

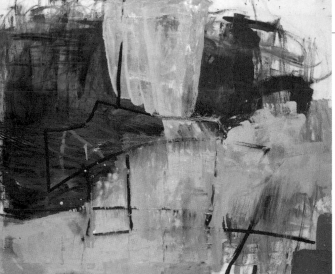

2. A sponge is used to apply oil paint that is very diluted with linseed oil in ochre and beige colors, covering the painting with two wet and thin masses. Then, a linear structure with burnt sienna paint applied directly from the tube is constructed. Both areas are allowed to blend a little bit and to interrelate freely.

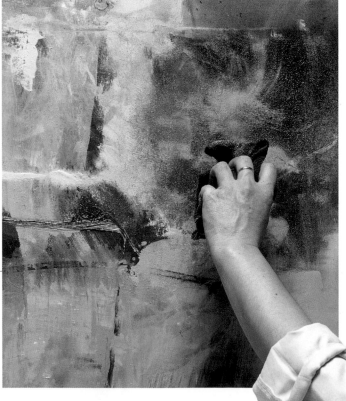

3. A white glaze is painted on the edges, which will provide light. Then, the oil paints are mixed with transparent varnish to create an atmospheric feeling that glazes the forms and softens them. The viscosity of the varnish and the pastiness of the oils are combined to provide a new dimension of texture.

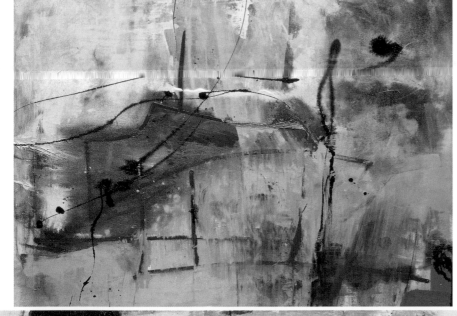

4. Before continuing the painting is allowed to dry a little bit. Then, the round brush is wet with India ink and, with a light movement of the hand, it is dripped over the canvas. Do not allow the brush to touch the painting directly; this will promote a gestural, light, and dynamic stroke.

5. To finish, the artist incorporates two large areas of India ink that provide the contrasting textural finish. The opacity of the India ink contrasts with the transparency created with the mixture of oil and varnish. Since this is a dry medium that is applied over an oil medium, a small amount of detergent was added; this way neither the oil nor the varnish repelled each other.

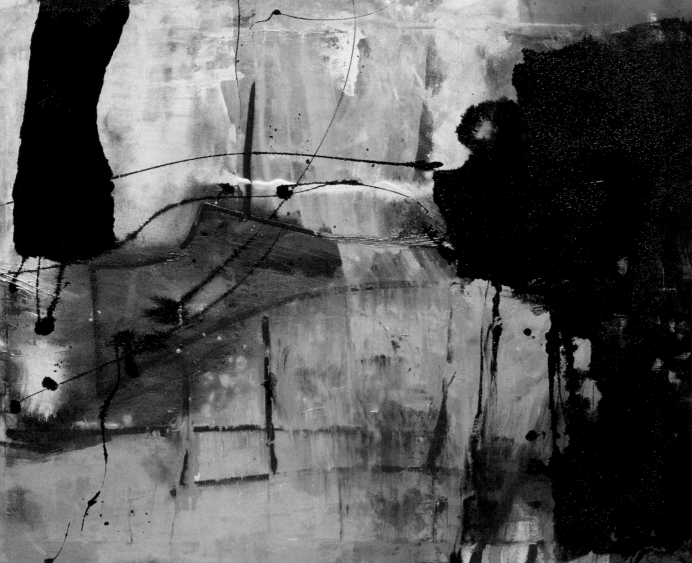

Creative techniques **oil**

Wishing to further experiment with different media, a gallery has been developed, where the variety of techniques has been the main focus. Varnishes, sprays, enamels, metallic paints, and acrylic paints have been mixed with the main medium—oils.

Several strokes of light brown oil paint were applied with a spatula on heavy paper. Over this and in the middle section of the work, large drops of cherry colored varnish were dripped, which mixed naturally with the oil paint in some areas. Finally, the artist painted a large central area of color with synthetic enamel paint, more frequently used to protect black metal parts.

Covering an old canvas with a very diluted white oil base created an interesting glazed background over which are worked three materials: asphaltum, oil paint, and transparent oil-based varnish. The central structural elements with dripping were created with asphaltum, the light color glazes with oil paints reduced with stand oil, and the upper areas of reddish brown color are a mixture of oils and varnish.

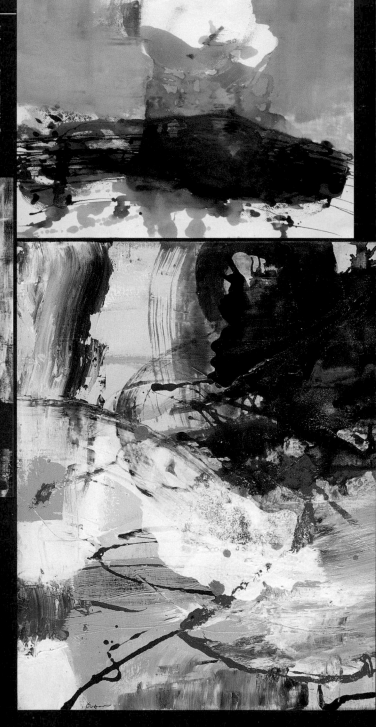

This piece is very different from the rest because it has almost a three-dimensional feeling thanks to the addition of elements of collage. The base was created with pieces of fabric, first glued together and then onto the paper base. Over this fabric pillow the artist applied a layer of white oil paint, and over that small touches of metallic enamel. The result is poetic and at the same time expressive.

This piece was painted on recycled paper. First, color was applied to the background, soaking the paper with a dispersion of black oil-based enamel paint in a water pan. Once the color was dry, dark varnish was poured over to create a translucent area of color. Finally, oil paint was applied to complete a clean and contrasted work of mixed media that never actually mix together.

This piece was worked on a wood board primed with gesso; the wood allows the artist to scratch the paint without damaging the support. The painting was begun with acrylic paint, basically extended with a spatula, creating blends and impastos. Since acrylics dry fast the artist continued with walnut colored varnish, white oils, and synthetic enamel of an ivory color, at times blending the substances together to create gradations and impastos.

14 Window

New
approaches

Another view All of the previous works experimented with mixed media in square formats, which can usually be found in art supply stores. This time, the artist has decided to approach the piece from a different angle with a somewhat unconventional format: a polyptic made of four wood boards in the shape of a giant "T." In this large piece, 100 inches (250 cm) high and 80 inches (200 cm) wide with the arms stretched out, she has mixed two media: oils and gold-colored enamel, applied with brushes and spatulas. A polyptic of these dimensions provides an updated view to the idea of the altarpiece and brings a new approach to traditional concepts.

Another model Continuing with the idea of using the model as a source of inspiration and not as an image to be copied, Gemma Guasch has chosen a night scene, a suggestive image that is out of focus. The blue colors and the charged atmosphere of the moment are transmitted with elegance in this new work painted on a very large wooden board. She has used oil paints applied with a wide household brush and a spatula, and silver colored metallic paint to render a liberal interpretation of the light theme at night.

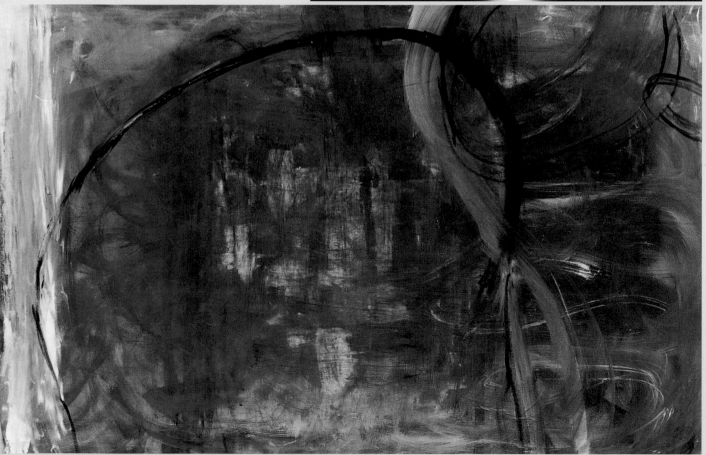

Form

Form and how it is perceived

Form is, on one hand, the external appearance of objects, and on the other, the mental model that helps us identify them. We recognize forms by their structure, which is determined by the outlines of the object or its interior skeleton. As we look at it we relate that structure to our accumulated previous experiences in our memory. Perceptively, we do not need the complete information about a form to

BASIC CONCEPTS

Abstraction

An abstraction is an image in which we cannot identify known forms of reality. This does not mean that reality does not contain abstract forms, for example the wear and tear on an old door, the structure of a building, or the view through a microscope.

Abstraction of organic forms

Chiaroscuro

Forms can only be seen because light shines on them. The light also creates shadows that are as important as the light, as are all the intermediate values. Chiaroscuro is the name for this play of light and shadow.

Chiaroscuro

Outlines

Outlines do not exist in reality; they are a linear interpretation made by the artist to indicate the edges of forms in respect to other forms or the background.

Outlines

Deconstruction

In drawing or painting, this refers to changing a shape or form by erasing, deforming, overlapping parts, or creating ambiguities to lose the correctness of that form. The objective is to give expression priority over representation.

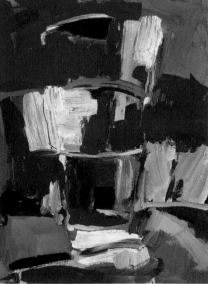

Deconstructed painting

Skeleton

The formal skeleton is the internal structure that all objects have. Sometimes this skeleton is real, like that of the human body; other times it may be a geometric figure that is contained within the form, like a sphere, a cube, or a cylinder.

Formal skeleton

Stylize

In painting, this word is used to designate the action of varying the form according to a "style." We can compare how different painters with strong personal styles treat the same form: some make it thin, others blow it up, some make it geometric, while others make it angular, fragile, or soft.

Stylized portrait

recognize it (in figure **A** we recognize a square with just the corners), furthermore, we can direct perception, since it is a mental process and not merely a reflective act (in figure **B** we see the arrows whichever way we please, pointing up or down).

Mass

This is the space that the form occupies in the painting. Mass implies a visual weight and that weight is determined by its size and the density of its brightness and color. A large mass of light or diluted color has less weight than a smaller mass of dark or dense color.

Mass

Modeling

This is a painting technique applied to the form to create a sense of volume. Modeling in painting is very similar to that of sculpting, since the same factors are involved. On one hand, mass is added and subtracted by controlling the intensity of the color and the amount of dilution of the paint; on the other the brushstroke is applied in the direction that the hands would follow if one were touching the volume with eyes closed and trying to discover its form.

Layout

The first steps in a painting are very important because they distribute the elements that compose the image. One manner of doing this is from inside to outside, that is, from the essence to the details. In this manner, one method of creating the layout is blocking-in, which consists of placing forms in "boxes" or basic figures (cylinders, cones, spheres, cubes, ellipses, etc.). A less academic method consists of using intuitive shapes to indicate each one of the forms.

Layout using precise outlines

Layout made with areas of color

Silhouette

The silhouette is defined by the edges of the mass in space. It does not show any details, but it allows us to understand the form.

Silhouette

Synthesis

Synthesizing is reducing information to a minimum, leaving only what is essential for understanding the form. We can synthesize with line, reducing the outlines to just what is required, or with color to indicate the silhouette, or with chiaroscuro based on light and dark values.

Synthesizing with color

Tenebrism

This term originated in painting during the Baroque period. In a Tenebrist painting the light emerges from the darkness, causing a certain theatrical effect.

Color

Color and how it is perceived

Color is a perceptive phenomenon. Objects are not "of" a certain color; rather the color is "perceived" in specific conditions of light. A sheet of paper is perceived as white in the sun, blue gray in shadow, and yellow under the light of a lightbulb.

Isaac Newton (1643–1727) discovered that white light can be split into a chromatic spectrum when it goes through a transparent prism. This is the same effect that causes a rainbow when sunlight is seen through drops of rain: the colors

BASIC CONCEPTS

Color wheel

If we were to join the first and last colors of the chromatic spectrum (magenta and violet) we would make a circle. In this circle there are three pure colors, which cannot be created by mixing any others. They are the primary colors: magenta, lemon yellow, and cyan blue. Mixing the primaries with each other will create the secondary colors: orange red, intense green, and blue violet. Mixing them will create the tertiary colors: green blue, yellow orange, etc.

Chromatic chiaroscuro

There are two kinds of chromatic chiaroscuro: value and colorist. In value chiaroscuro a color ranges from its lightest tone, mixed with white, to the darkest, mixed with black or its complement. On the other hand, color chiaroscuro uses neither black nor mixtures of complementary colors, since it is about clean or pure colors. In this case the painter works with pigments that are naturally bright or dark.

Adjacent colors

Two colors are adjacent when they are near each other on the color wheel.

Warm colors

This is the range that goes from violet to green yellow. Visually they give off a sensation of warmth. Black is a neutral color but it tends toward warm.

Warm colors

Complementary colors

Two colors are complementary when they are opposite each other on the color wheel.

Cool colors

This is the range that goes from blue-violet to green on the color wheel. Visually they impart a cool sensation. White is neutral but it tends toward cool.

Cool colors

Neutral colors

A color is neutral when it has been mixed with its complementary color. They look gray and dark because they have lost their brightness.

Neutral colors

Pastel colors

These are colors with pastel tones. Because they are mixed with white, they have become lighter than normal.

Pastel colors

of the rainbow are the chromatic spectrum. When light strikes an object, it absorbs all the colors of the spectrum except one, which is reflected to the viewer. This is the color of the object in that condition of light.

Saturated colors

A color is saturated when it contains no amount of its complementary color, neither black, nor white; that is to say, a totally pure color with all its natural energy.

Saturated colors

Contrast

There are three kinds of color contrast. At a tonal level, among the colors on the color wheel the maximum contrast exists between the complementary colors. At the level of brightness, light colors contrast with dark colors. And third, saturated colors contrast with neutral colors.

Divisionism

This painting technique consists of applying deconstructed and pure colors on the canvas in small dabs. These are later mixed in the eye of the viewer and maintain all their natural luminosity. The first Divisionists were the Pointillists, at the end of the nineteenth century.

A B

Interaction of color

Range

This is the name for the group of colors applied to the canvas. This is sometimes called harmony, since it refers to how the colors interact with each other. For example, a monochromatic range is based on a single color, and a harmonic trio consists of the colors that are found at each corner of an equilateral triangle on the color wheel.

Monochromatic range

Harmonic trio of secondary colors

Interaction

A single color can look different according to the color around it. A gray, for example, can seem cool if surrounded by warm colors (**A**) or warm if it is surrounded by cool colors (**B**).

Tone

This refers to the position of a color on the color wheel, not to its light or its purity. The term is also used in the same sense as the word shade, therefore the tone—or shade—of a color can be blue, orange, red, etc.

Value

This is the brightness of a color. On the color wheel the brightest color is yellow, and the darkest is violet; furthermore, each color can become lighter or darker as it moves toward white or black.

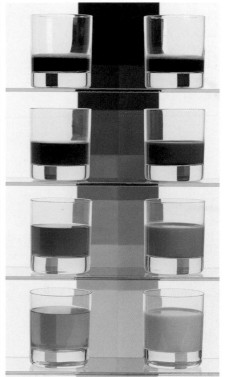

If coffee is diluted with water its value lightens but it maintains its tone; however, if the dilution is done with milk, it becomes lighter or more pastel. The same happens with paint when a color is lightened by diluting it or by adding white.

Color vibration

This concept is used very often in painting to refer to elements of color contrast in a painting. This vibration can be subtle or very intense depending on the amount of contrast.

Space

Space and how it is perceived

Space is perceived visually because of two factors: light and perspective. On one hand, light makes the perception of depth and volume possible. On the other, perspective helps us establish relations of distance: things that are nearest are seen to be larger, clearer, and have more contrast. Let's look at some perceptions related to space: Gradations (**A**) cause a visual sense of depth; in general, darkness looks more distant than light. Perspective fundamentally works by diminishing the

BASIC CONCEPTS

Atmosphere

In painting, atmosphere refers to a sense of airy density. When a painting uses atmosphere it seems that the paint fills the air with particles, making it dense and tactile, like steam, fog, or dust. Blending, layered glazes, and dry impasto are often used to diminish the clarity of scene.

Alfred Sisley, Fog, Voisins, *1874. Musée d'Orsay (Paris, France). Atmospheric painting.*

Composition

This is what we call the distribution of elements in space. It obeys the artist's expressive intention and establishes a visual movement: central elements catch one's attention, then secondary aspects, then marginal ones. Compositional sketches are often followed to ensure visual balance.

Framing

This is the selection of the scene. Framing includes the format (square, horizontal, etc.), nearness (moving closer to or farther from the scene), and the point of view (side, frontal, angled, etc.).

Framing a landscape.

Compositional scheme

This is the synthesis of the composition, a general sketch of the distribution of the elements. Some compositional schemes in painting are now standard, like centered composition, very balanced and static, which centers the subject in a geometric figure like a triangle (**1**), and orthogonal, based on vertical and horizontal lines (**2**). More dynamic schemes are the diagonal (**3**) and those that organize the masses along curves (**4**).

1

sizes of objects (**B**). Overlapping (**C**) consists of defining near planes that partially cover objects; the closest objects, or planes, hide parts of the others. Finally, playing with focusing and blurring objects will also create distance (**D**), an approach that was learned from photography.

A

Format

By format we mean the form of the painting, although the term is also used to describe the size of paintings (small format, large format). The most common formats are rectangular (**1, 2**), although the square (**3**) and horizontal (**4**) are also common, especially for painting landscapes.

2

Figure and background

A classic problem that must be resolved in a painting is the relationship that is established between the figure and the background. A decision must be made about whether they should be visually separated or not. The background should be considered a fundamental part of the work, not just the physical support of the subject. To integrate the background and the figure well it is a good idea not to use excessive contrast between the two.

3

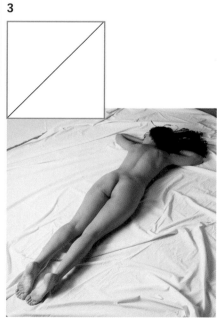

4

Proportion

In painting, proportion and scale are very similar concepts, since both refer to the relationship of the size or the distance between objects. To create the sensation of space it is common practice to create large differences in proportions.

Rhythm

This is the unity in change and variety. Rhythm creates a sense of movement in the painting and is caused by the repetition or alternation of forms following a cadence. Varying the intensity or the positions of the objects can cause visual movement and direct the viewer's eye. Fullness has as much importance as emptiness in the rhythm, just like sound and silence exist in music.

Projected shadow

Projected shadows are the silhouettes of the forms on the plane where they are projected by the position and intensity of the light on the forms. They are an excellent recourse for creating a sense of spatial depth.

Andrew Macara, The Badminton Match, Tenerife. *Private collection. Perspective in the projected shadows and strong visual rhythm in the entire painting.*

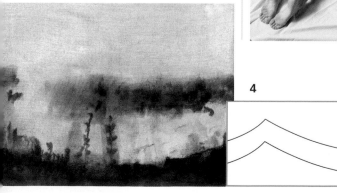

Creative techniques **oil**

Line

Line and how it is perceived

Line is the physical dimension of the painting. While form, color, and composition are elements that refer to the "what" of the painted image, the line refers to "how" the image was physically created. It is related to the materials and the intentions with which the image was created, basically referencing two aspects of the work: the texture and the gesture. In the former the material factors come into play—support, materials, and applicators. In the latter it is the technique, speed, intensity,

BASIC CONCEPTS

Alla prima

This is also called *au premier coupe*. *Alla prima* is an Italian expression used to designate all painting that is done "the first time." This does not mean that the painting must be done in a hurry, but that the artist makes what can be the definitive lines and brushstrokes from the beginning. This method makes sense for paintings created in a single session, and it is used for painting landscapes or the human figure to achieve fresh and direct results.

Gradation

When one color changes to another in a gradual manner we call it a gradation. It can be blended and even be very light, or not, showing each individual color separate from the next one, with smooth or textured brushstrokes.

Blended gradation

Gradation without blending

Sgraffito

This term refers to the technique of scraping or scratching. It is also sometimes called *grattage*. It consists of scraping a layer of fresh paint to expose the color of an underlying layer that has already dried.

Sgraffito

Gesture

The gesture is a matter of modulating the lines or strokes. It is related to the movements of the hand, and by extension the arm and the position of the body. An understanding of the expressive possibilities of the gesture in painting is perfectly understood today; however, it is recent. It is owed to the rich influence of Oriental painting, which has a long tradition in this field, and to Western contributions during the twentieth century, such as Abstract Expressionism.

Glacis

In this book the word glacis is used to designate a specific style created on dry paint. It consists of applying thin layers of color that do not cover the entire surface and allow the previously applied paint to show through. The layers are created by painting dry on dry, dabbing and dragging without ever blending the colors on the canvas. The optical mixture is later produced in the retina of the viewer.

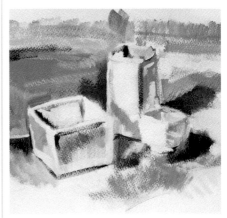

Glacis

Dabbing

This is sometimes called impression, since it is the result of the pressure of an applicator on the support without dragging the color, and using more or less precise touches. Less typical applicators are often used, like fingers, folded rags, sponges, and the surfaces of various objects.

Wash

In painting, wash means eliminating paint that was previously applied and that is in a more or less advanced state of drying. To wash a painting, or part of one, solvent is applied directly, with a rag, or with a sponge, and then dried with a rag. By controlling the flow of the solvent, and the pressure during the wiping and the drying, we can create more or less dense atmospheric effects and leave rough edges on areas of paint.

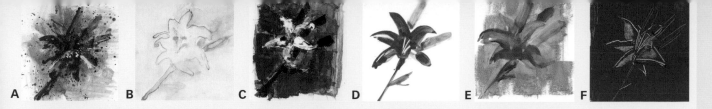

A B C D E F

and modulation. Using the same model we express ourselves differently with a quick diluted stroke with a lot of splashing (**A**); with a slow line wash with barely any paint (**B**); with heavy and flat applications of paint made with a spatula (**C**); with a clear brushstroke of paint that is flowing, slow, and concise (**D**); with deft applications that both add and remove atmospheric color (**E**); and with a scraped line that is controlled and fine (**F**).

Juxtaposed colors

Normally, oil painters work wet on wet, with colors blended on the canvas and impastos. However, transparent effects can also be created by using juxtaposed and overlapping areas of color. When one transparent color covers another a visual blend is created. This is one of the most popular techniques for making glazes.

Juxtaposed colors

Sfumato

The meaning of this term, which originated in Italian Renaissance painting, is related to the atmospheric effect of the brushstroke. This technique consists of applying a brushstroke with relatively little paint and eliminating the sharpness of the outlines of the figures by blending their edges.

Sfumato

Texture

This is the tactile dimension of the painting. It can be a visual texture created by dabbing, touching with the brush or a spatula, wiping, splashing, dripping, and so forth; or it can be a truly tactile texture based on impastos, fillers, collage, supports with relief, etc. The textural dimension of a painting adds expressiveness and communicates a great sense of reality because it surpasses the virtual image.

Hatching

This refers to an area of color created with lines that are applied with parallel strokes and often crisscrossing. The grid created by doing this can be more or less dense and will equate to a particular chiaroscuro value. Hatching can also be done with dots, although this is less common.

Glazing

A glaze is an area of color, large or small, made with very diluted paint with solvent, oil, a mixture of the two, or a medium. The diluted color becomes more transparent and allows the colors underneath the glaze to be seen. This is the most typical way of applying a glaze, with juxtaposed layers, although they can also be applied planning for later washing or making blends and gradations on the canvas while the layer is still wet.

Texture with filler

Glazing

CREATIVE PAINTING

FORM
COLOR
SPACE
LINE

FORM
CREATIVE PAINTING SERIES
BARRON'S

COLOR
CREATIVE PAINTING SERIES
BARRON'S

SPACE
CREATIVE PAINTING SERIES
BARRON'S

LINE
CREATIVE PAINTING SERIES
BARRON'S

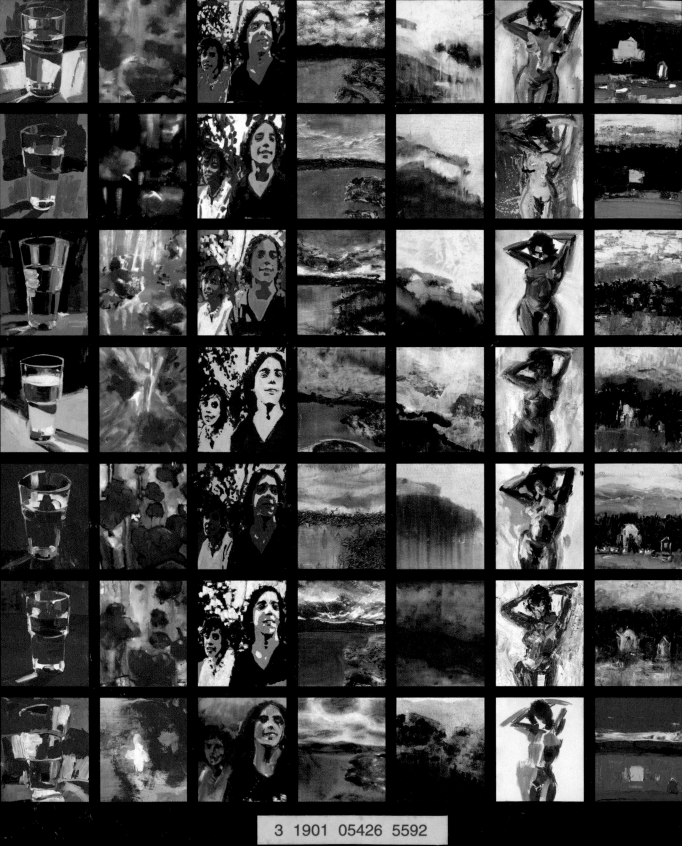